POSTCARD HISTORY SERIES

Philadelphia Neighborhoods

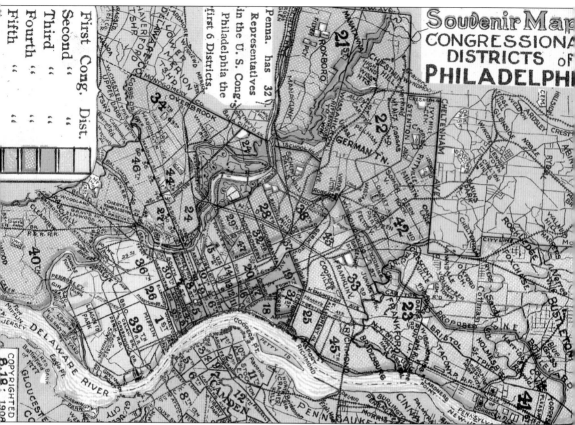

This map is actually a postcard detailing the Philadelphia congressional districts and city wards as they were in 1908. It is certainly not the usual and customary "having a great time, wish you were here" sort of greeting from Philadelphia. The bold numbers on the postcard refer to the various ward districts.

On the front cover: The Playgrounds Association of Philadelphia produced this thought-provoking postcard in 1908 titled, "A Feeder for the Juvenile Courts." It advertised that "the gutter breeds crime," but $1 bought one child 40 days of wholesome play. (Author's collection.)

On the back cover: South Philadelphia has always been known for its street corners, where guys would hang out in great numbers. A much younger group is seen at the corner of Second and McKean Streets in 1907 in front of Harry F. Mohr's dairy store. (Author's collection.)

POSTCARD HISTORY SERIES

Philadelphia Neighborhoods

Gus Spector

ARCADIA
PUBLISHING

Copyright © 2008 by Gus Spector
ISBN 978-0-7385-5744-1

Published by Arcadia Publishing
Charleston SC, Chicago IL, Portsmouth NH, San Francisco CA

Printed in the United States of America

Library of Congress Catalog Card Number: 2007937782

For all general information contact Arcadia Publishing at:
Telephone 843-853-2070
Fax 843-853-0044
E-mail sales@arcadiapublishing.com
For customer service and orders:
Toll-Free 1-888-313-2665

Visit us on the Internet at www.arcadiapublishing.com

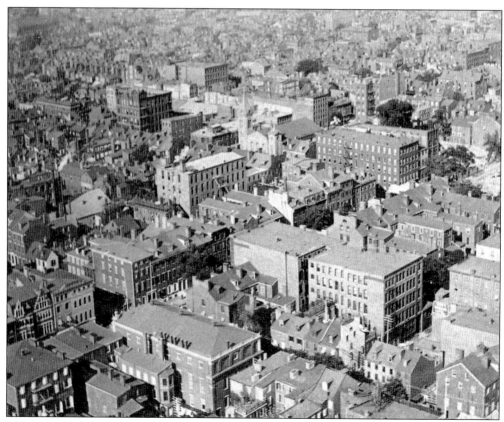

This is an 1891 aerial view of a large area of Philadelphia row houses. It is taken from a stereopticon card that clearly illustrates why Philadelphia is known as "the City of Homes."

CONTENTS

ACKNOWLEDGMENTS

I wish to express my wholehearted thanks to Erin Vosgien, the editor of all three of my Arcadia books. Always there with ready encouragement and advice, she has greatly facilitated the transition from idea to the printed page.

To Eileen Wolfberg, I offer my sincere gratitude for reviewing my text and for her insightful comments and corrections.

I am most thankful to Clarence Wolf, who has again demonstrated his flair for things historic and for his knowledge of Philadelphia's neighborhoods.

Most of all, I am extremely lucky to have Karen Spector as my wife and best friend. Although not involved in the writing aspect of my books, she has been my ultimate supporter and local public relations person.

INTRODUCTION

This book is written in praise of the itinerant photographers who roamed the streets of Philadelphia during the first decade of the 20th century. They were the entrepreneurs who canvassed the various areas of North Philadelphia (including Logan, Olney, Mount Airy, and Germantown), Southwest and West Philadelphia, South Philadelphia, and Kensington, traveling and travailing throughout the year in all sorts of weather. Some of these extant photographs were actually snapped when there was two feet of snow on the ground. Had it not been for their ingenuity, diligence, and the need to make a buck, records of many fledgling areas sprouting up about the city might never have existed.

Whether it was purposeful or by happenstance, the roving photographers managed to capture the signs of the times. Street scenes contained views of buildings adorned with the original hand-painted tin advertisements that are sought today by antique dealers and collectors.

Many of the photographers captured the streets' local inhabitants, making the images more credible, timely, and, of course, more saleable by the vendors. In doing so, they have provided us a quick snapshot into the era's manners and fashions along with children gesturing and romping about in the streets.

Various modes of transportation have always been a special highlight of these cards. I had to laugh out loud when an eBay seller described a real-photo postcard as containing "views of antique cars." Did this seller not realize that those cars were, at the time, far from antique?

Since automobiles were a new commodity in the first decade of the 20th century and not generally affordable, most of the street scenes were barren save for a single posed vehicle. It should be remembered that the narrow city streets were planned with the horse-and-buggy trade in mind, not for the eventual onslaught of the automobile industry.

Untold fortunes were made by those having the foresight and capital to finance and plan the street railways of Philadelphia. The history of the growth of West Philadelphia is, in fact, the very history of the spreading tendrils of the public trolleys and railways to reach ever further away from city hall.

The moguls of transportation keenly realized that the masses longed for diversion in their humble lives, and what could have been more fun than a weekend trip to an amusement park? Woodside Park, just beyond Fairmount Park, and Willow Grove Park, miles beyond the northern city limits, were created as family getaways that could be reached by the trolleys owned and operated by these same magnates.

Row houses have been a long-standing hallmark of Philadelphia. The predominant raisons d'être for their design have always been that the rooms were suited for the average family's needs,

their general structural efficiency, and the ability to utilize minimal amounts of common public land, water, and sewers.

In this volume, I have turned my attention to Philadelphia as the City of Homes and the "city of neighborhoods." Philadelphia is famous for its miles and miles of row houses that are all so similar yet all so different. I do not dwell on the reality that many of these inner-city areas have become dilapidated, dangerous wastelands. I also have not touched on the wonderful, ongoing urban renewal projects in many other districts.

Thanks to the section titled Neighborhoods (pages 137 through 151) in the 1994 edition of the *Philadelphia Almanac and Citizens' Manual*, I have been better able to describe the boundaries of each of the city's subdivisions. For example, North Philadelphia is divided into the neighborhoods of Nicetown, Tioga, Kensington, Fishtown, Bridesburg, Wissinoming, Frankford, Allegheny West, Franklinville, Brewerytown, and Strawberry Mansion. The sections of Logan, Olney, East and West Oak Lane, Fairmount, and Spring Garden are indeed part and parcel of North Philadelphia, but I have deliberately focused on them in separate chapters.

Many readers will remember these landscapes as they appear here and the fond memories of good times shared with friends and neighbors. They will remember the fruit and vegetable hawkers' wagons, the ice deliveryman handing out cold, dripping shards from the frozen blocks within his open, horse-drawn truck, and the occasional merry-go-round with its hurdy-gurdy music pulled along by a flea-bitten, tail-swishing nag. They will remember the summer days splashing under the force of a fireplug's cool spray and the endless summer nights when, as children, they could play games in the street late into the evening. This, then, is a celebration of a time irretrievably and irrevocably gone but happily captured on old picture postcards.

In creating this book, my original intent was only to portray the street scenes snapped by these errant photographers. However, as I began my research, I quickly realized that a neighborhood consisted not of streets and homes alone, but of its surrounding factories, places of worship, corner grocery stores, and, yes, its local saloons. I have attempted to tie all of this up into a neat little bundle in order to best present the past.

My other initial goal was to annotate each chapter with scans taken from a 1905 map of Philadelphia in an effort to better orient the reader as to the location of the streets and byways. This failed for two reasons. First, for purposes of conservation of space, one would be in great need of a high-magnification lens in order to see particular landmarks in small spot maps; second, I would have filled the entire book with bland, boring maps rather than with the interesting photographs derived from my collection. Therefore, to look for specific locations of interest, it is suggested that the reader consult one of the many available city maps.

I have taken the liberty to include several family photographs from the 1940s and 1950s. Of course, my "only" reason for doing so was to illustrate their juxtaposition to the Philadelphia neighborhoods they inhabited!

One

A Streetcar Suburb Named West Philadelphia

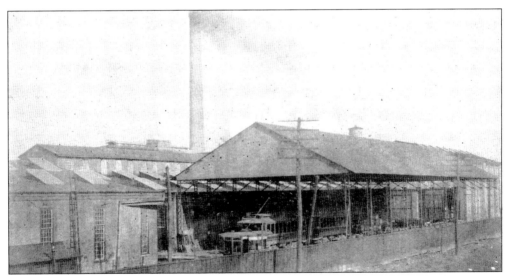

The J. G. Brill Company was the world's leading manufacturer of trolleys and railroad car undercarriages. Their plant was located at Thirty-first and Chestnut Streets, in what is now called the University City section of Philadelphia. J. G. Brill, a German immigrant, founded the company in 1868. The company played an integral part in the development of West Philadelphia as a streetcar suburb. In its glory days, it produced between one third and one half of the nation's trolley cars. By the 1940s, it was unable to compete with the up-and-coming bus industry and eventually faded into oblivion.

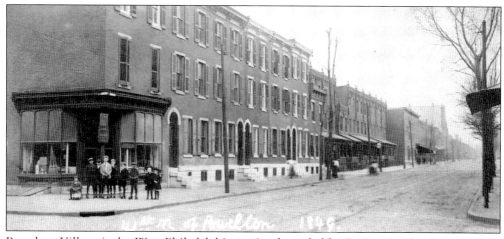

Powelton Village is the West Philadelphia section bounded by Spring Garden Street on the north, Market Street on the south, Thirty-second Street on the east, and Forty-fourth Street on the west. The neighborhood consists of mostly twin Victorian homes. This 1905 scene features Forty-first Street north of Powelton Avenue, which contains a mixture of architectural styles.

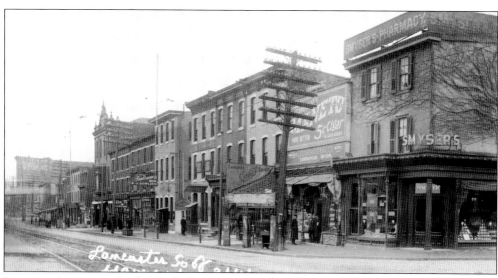

Lancaster Avenue south of Haverford Avenue is seen in this postcard from about 1905. Lancaster Avenue was a busy commercial thoroughfare in the west Powelton area. The street is graced by a pharmacy, a cigar store, and a beer saloon complete with ladies' entrance.

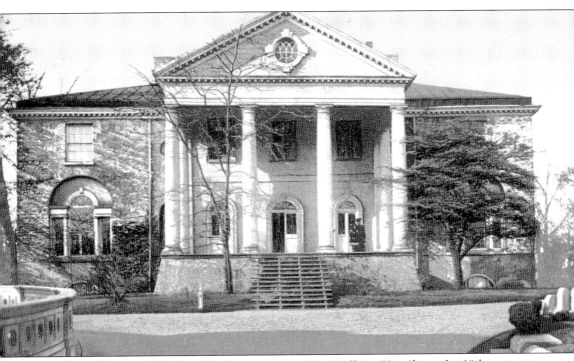

Hamiltonville was originally a family estate owned by William Hamilton, the 18th-century owner of most of the land that later became known as West Philadelphia. It sprawled from east of Forty-first Street to west of Thirty-third Street and from Filbert Street to north of Woodland Avenue. Hamilton unabashedly changed the official city street names to those of his family members. Walnut Street became Andrew Street, and Chestnut Street became James Street. The historic Woodlands mansion, located at 4000 Woodland Avenue, seen in this 1905 view, has been preserved and remains open to the public.

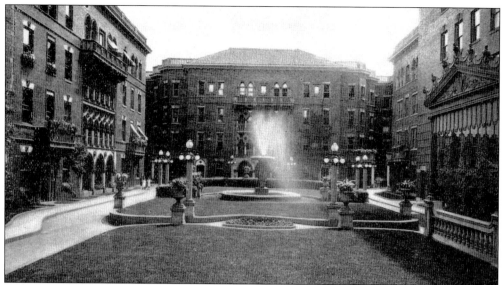

After 1827, the Hamilton heirs sold major portions of their 250-acre estate. In the 1840s, Philadelphia upper-middle-class families purchased plots of land from them and erected magnificent suburban villas. The Hamilton Court Plaza, built in 1901 and located at Thirty-ninth and Chestnut Streets at the site of Col. Constant Eaken's mansion, is seen in this resplendent 1911 setting.

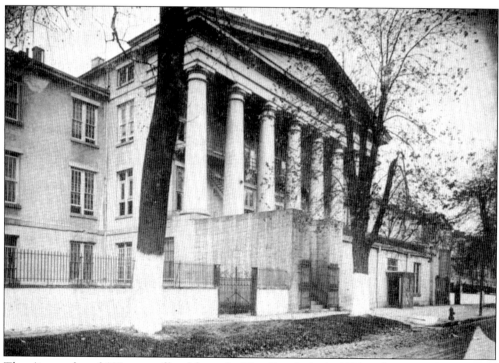

The city purchased 187 acres of land from the Hamilton heirs in 1832 and erected the Blockley Almshouse at Thirty-fourth and Pine Streets, designed by the well-known architects Samuel Sloan and William Strickland. A 1904 view of the building is seen here. This was, literally, the poorhouse.

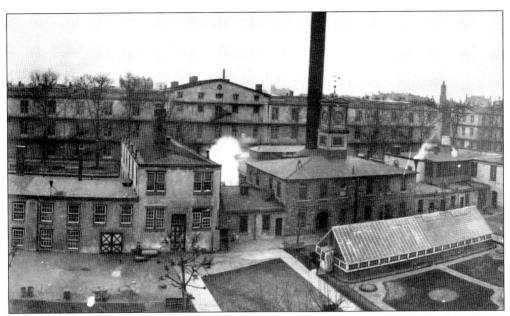

The Blockley facility grew into a city hospital, orphan asylum, and insane asylum. It became a small city unto itself, as evidenced in this 1910 bird's-eye view of the property.

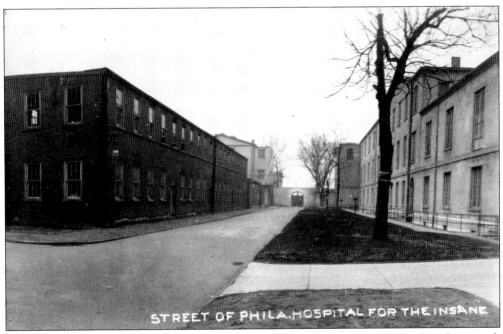

STREET OF PHILA.HOSPITAL FOR THE INSANE

The insane asylum was located on a lonely and foreboding street, as seen in this photograph from 1910.

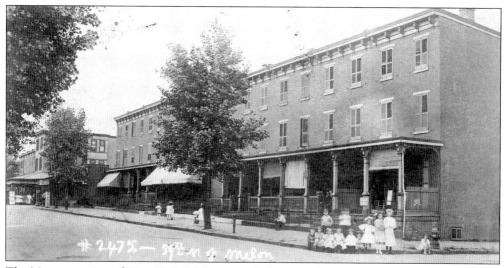

The Mantua section of West Philadelphia extends from north of Spring Garden Street, south of Mantua Avenue, east of Fortieth Street, and west of Thirty-first Street and is one of the older sections of West Philadelphia. Thirty-ninth Street west of Melon Street lies within this area and is viewed in this 1905 postcard.

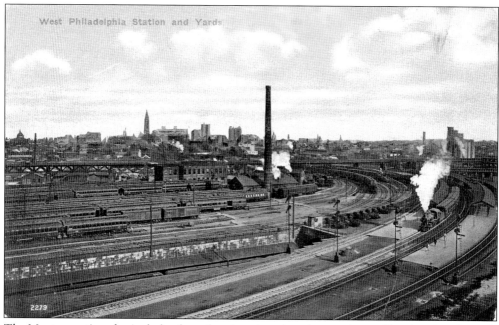

The Mantua section also includes the railroad yards and tracks entering and leaving the Thirtieth and Market Streets train station. This 1917 panoramic view of the yards faces eastward toward Center City.

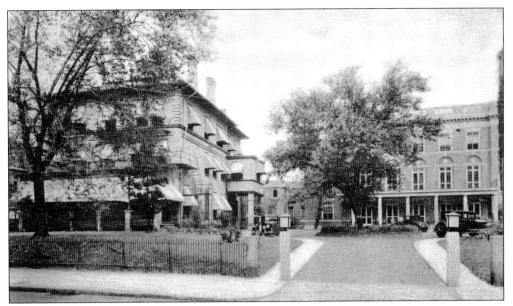

The West Philadelphia Hospital for Women was located at 4033 Parrish Street, opening in 1892 within the mansion of a deceased judge. By 1907, more property was purchased and the hospital underwent a vast expansion program. It was a busy hospital into the 1930s, and the building became part of the University of Pennsylvania in 1964.

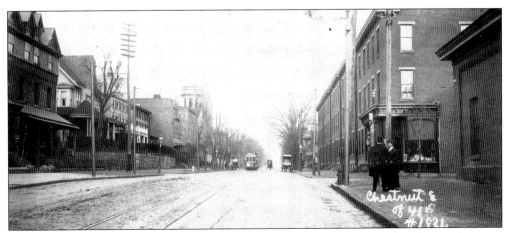

The Spruce Hill section was built up between 1850 and 1910. Spruce Hill is the area between Fortieth and Forty-sixth Streets from Market Street south to Woodland Avenue. In 1907, a traction trolley can be seen in the distance beyond Forty-first and Chestnut Streets, heading west. Chestnut Street was one of the important West Philadelphia streetcar lines.

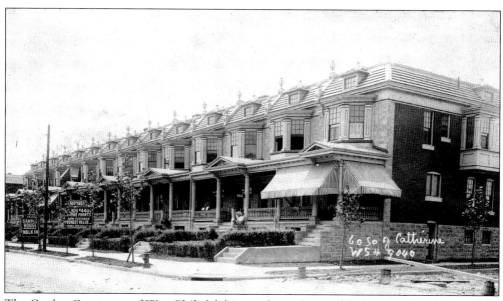

The Garden Court area of West Philadelphia was located east of Cobbs Creek and west of the Spruce Hill section. New construction can be seen in this 1907 postcard at Sixtieth Street near Catherine Street. These row homes, boasting open porches and stone fronts, were typical of this area. The asking price for the houses was $4,400 ($95,210 in 2006 dollars).

This is an interior view of a standard house at Sixtieth and Catherine Streets. Each set of adjoining homes was the mirror image of the one next door. The small living room contained a faux fireplace. Such advertising postcards were hand delivered to the neighborhood residents in the hopes that they might become potential customers.

The Cobbs Creek section of Philadelphia is bounded by Market Street to the north, Baltimore Avenue to the south, Fifty-second Street to the east, and Cobbs Creek Parkway (Sixty-third Street) to the west. In the latter part of the 19th century, the numerous tributaries flowing into the creek were either dammed up or converted into underground culverts as the area developed into a residential neighborhood. Cobbs Creek Park was the resultant preserve of this once-pastoral area. A glimpse of it is seen in this 1905 postcard.

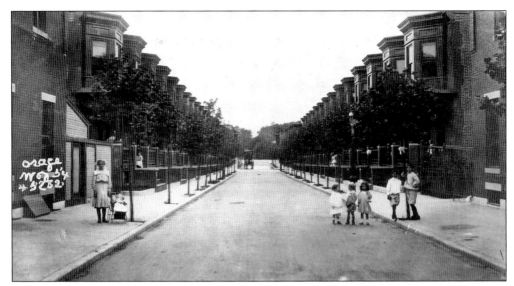

Fifty-fourth Street and Osage Avenue, seen in 1909, is located in the center of the Cobbs Creek section. In 1985, just 12 squares away (in the 6600 block of Osage Avenue), Mayor Wilson Goode sanctioned the bombing of the house occupied by the radical group MOVE. The explosion caused a massive fire, destroying several blocks of homes in the area.

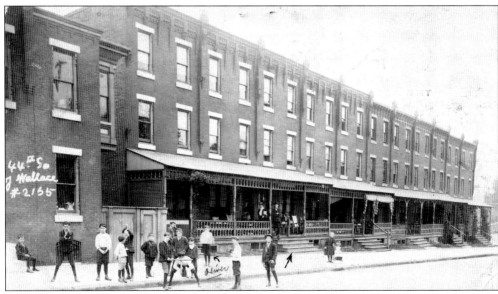

The Mill Creek section runs from north of Market Street, south of Girard Avenue, and between Forty-fourth and Fifty-second Streets. This photograph shows a nicely dressed group of children posing for the camera at Forty-fourth and Wallace Streets, which is located between Forty-second and Forty-fourth Streets, parallel to Haverford Avenue. The homes in this 1907 view were already older.

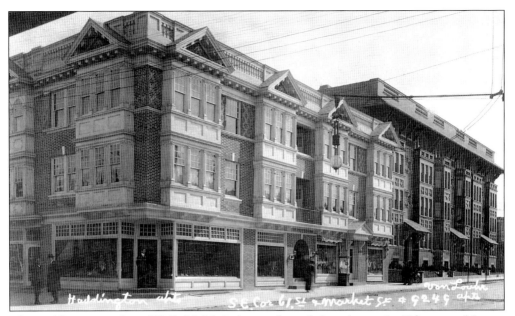

The Haddington section of Philadelphia is the area bounded on the east by Fifty-second Street, on the west by Sixty-third Street, and on the north and south by Girard Avenue and Chestnut Street, respectively. The Haddington Apartments, identified on the far left, were located at Sixty-first and Market Streets. The Von Louhr Apartments are seen on the far right in this 1913 postcard.

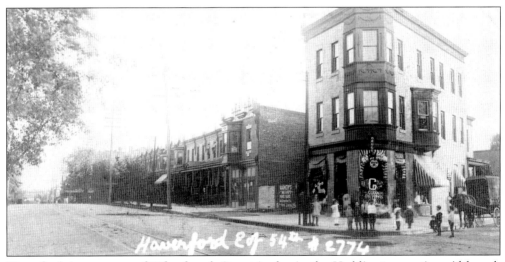

Haverford Avenue east of Fifty-fourth Street is also in the Haddington section. Although predominantly a residential area, a drugstore stands on the corner in this 1907 view.

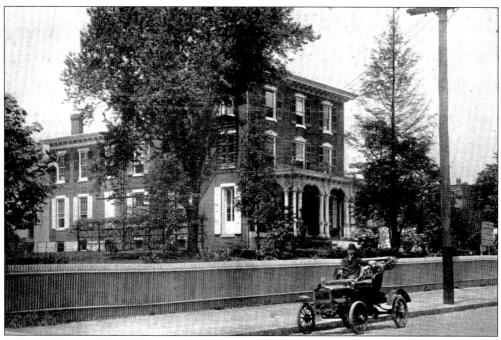

The West Philadelphia General Homeopathic Hospital, located at Fifty-fourth Street and Girard Avenue, opened to the public in 1905. Records state that this small hospital treated 350 accident cases per month in 1907, the year that this postcard was mailed.

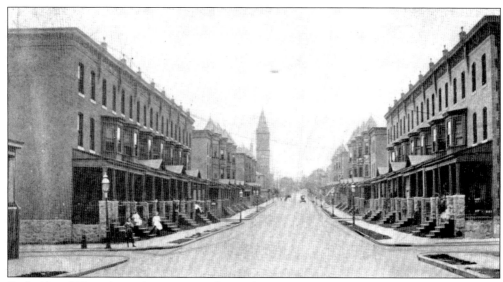

Both sides of Westminster Avenue west of Sixty-first Street are seen in this 1909 postcard. Built by Westney and Holbrook, they boasted two bedrooms, a sitting room, and a bathroom on the second floor, and three bedrooms on the third floor. The individual lots measured 15 by 25 feet.

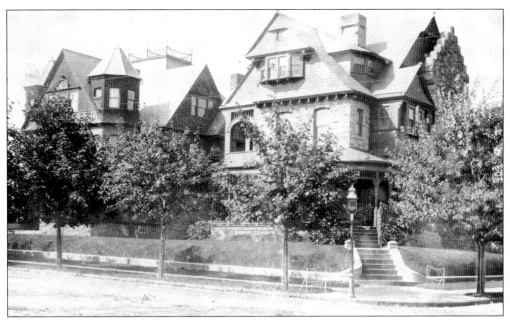

Cedar Park is another section of West Philadelphia, with its boundaries being Larchwood Avenue to the north, Kingsessing Avenue to the south, Forty-sixth Street to the east, and Fifty-second Street to the west. These elegant Victorian homes located at Forty-sixth Street and Chester Avenue lie just on the cusp of the Cedar Park area, as seen here in 1907.

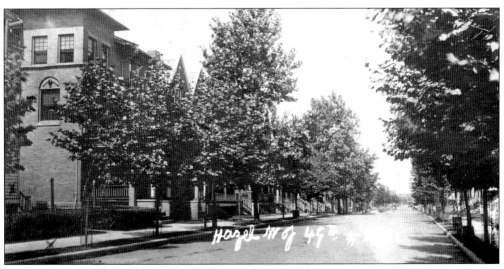

In 1907, the 4900 block of Hazel Avenue was a wide, delightful street, sporting young, tall, straight trees. The houses were built around 1900 as two- to three-story Colonial Revival twin residences, all with full width front porches and various degrees of stone and wood trim. There were several different roof styles, as can be seen in this view.

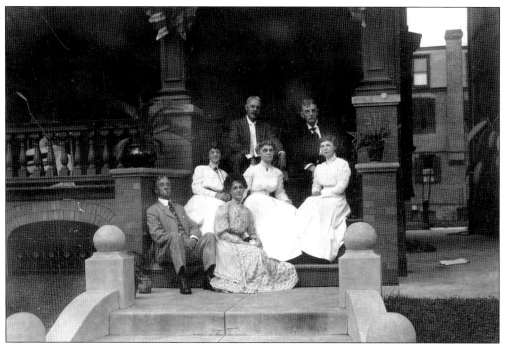

A group of well dressed, mostly elderly, people pose for this portrait on the porch at 5113 Hazel Avenue. The photographic postcard is dated 1910. The open-air porch is constructed of brick and stone with fancy wooden pillars.

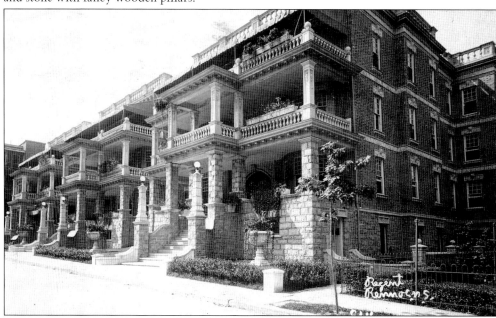

The Regent-Rennoc Court located at 1311–1327 South Fifty-second Street in the 5100 block of Regent Street was designed by E. A. Wilson. Wilson was the principal architect of mass-produced housing within the city of Philadelphia, having designed over 20,000 residential units. Seen in this photograph postmarked 1913, his creative apartment design contained amenities comparable to nearby row homes.

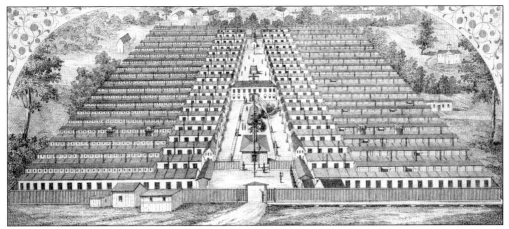

In 1865, Satterlee Hospital was the second largest army hospital in the country, containing 4,500 beds. During the Civil War, it was located in the fields between Baltimore Avenue and Spruce Street at Forty-fifth Street.

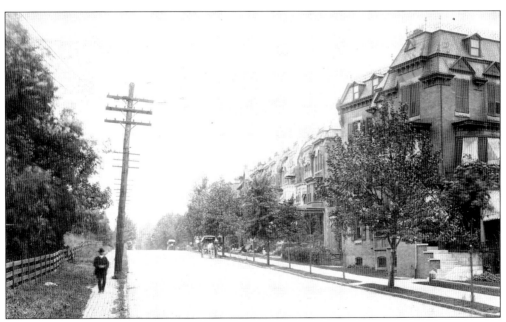

After the Civil War, the land occupied by the army hospital was developed into a handsome neighborhood. The fields were transformed into Clark Park, which was established in 1895, lying between Baltimore and Woodland Avenues and Forty-third and Forty-fifth Streets. The perimeter of the park, at Forty-fifth Street and Baltimore Avenue, is seen on the left of this 1907 postcard. The group of homes between 509 and 519 South Forty-fifth Street (those in front of the wagon) were built around 1898 by developer Robert Anderson.

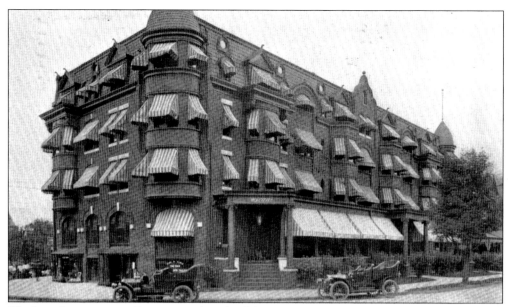

The Ivan Apartments at Forty-seventh and Baltimore Avenues were an impressive sight, as seen in this 1907 postcard. The building was listed in *The Philadelphia Blue Book Directory* for 1910.

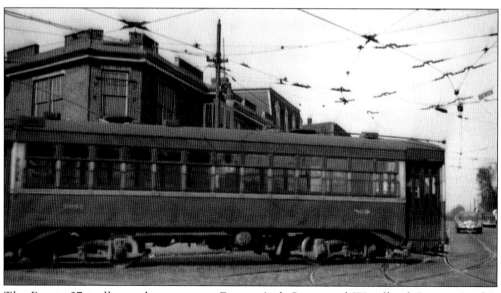

The Route 37 trolley makes a turn at Forty-ninth Street and Woodland Avenue in this 1947 view.

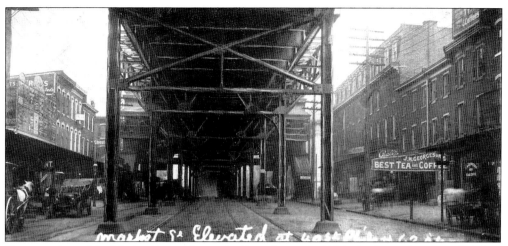

Construction of the Market Street elevated railway began in 1904; the first columns and girders were placed at Forty-fifth Street the following year. The elevated deck and railroad ties were joined in July 1906. By 1908, the buildings on either side of Market Street at Fortieth Street already had the weathered look of long usage. Homes, many of Civil War vintage, had been converted into storefronts.

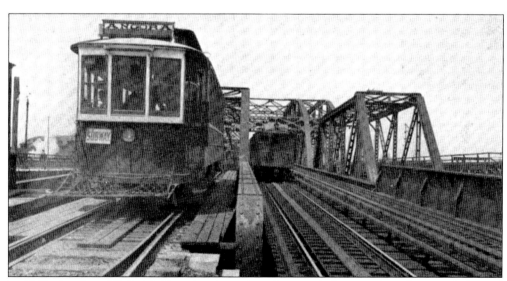

In 1909, the city of Philadelphia printed a series of postcards featuring its subway and elevated railroads. The construction of a train bridge over the Schuylkill River at Thirtieth and Market Streets was a giant step in linking the streetcar suburbs of West Philadelphia to Center City. The trolley heading to the Angora section is on a separate set of tracks from the train line. The trolley line ultimately had to be abandoned because of low clearance near the bridge.

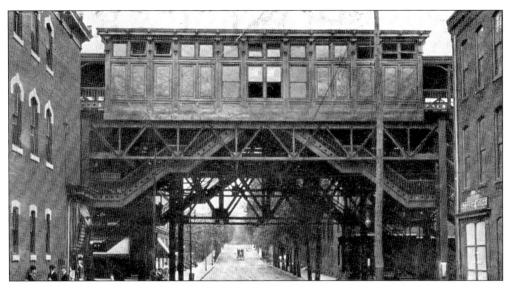

Another of the city's postcard series shows the elevated station at Fortieth and Market Streets.

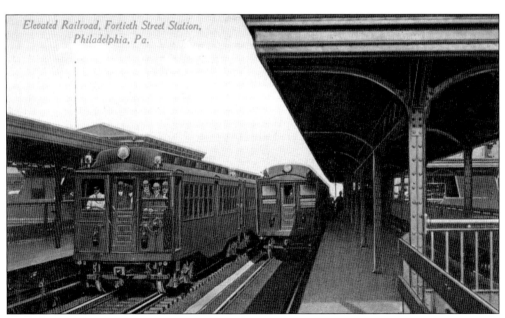

The stations on the West Philadelphia line were remarkably similar. Shown here is a 1907 view of the train platform at Fortieth and Market Streets.

This is the elegant Victorian home of M. Alice Miller at 111 North Fiftieth Street around 1911, located just above Fiftieth and Market Streets. The reverse of the postcard advertised that she was a parlor milliner, specializing in fur hats and capes, turbans, muffs, and the latest designs in fine French millinery, all at reasonable rates.

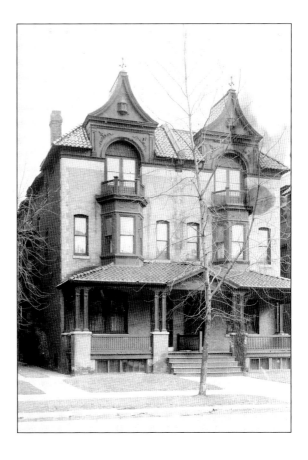

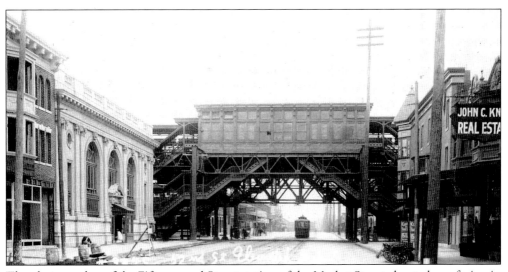

The photographer of the Fifty-second Street station of the Market Street elevated was facing in a southward direction when this view was taken in 1908.

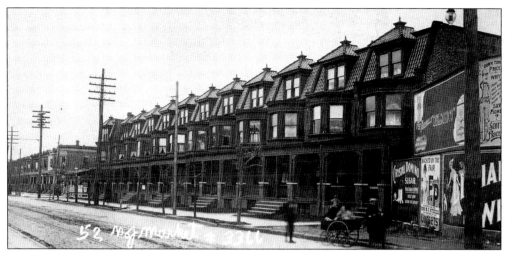

From its Market Street perspective, the entire west side of North Fifty-second Street can be seen. Notice that the entire block has a residential air.

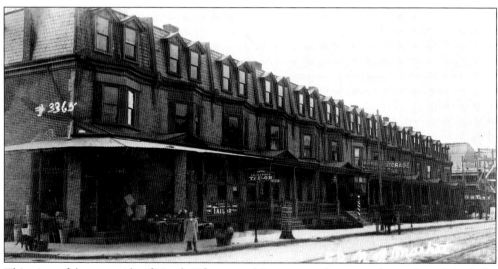

This view of the same side of North Fifty-second Street was taken several years later. It includes a glimpse of the elevated station on the far right. The once-residential thoroughfare is now also populated by a barber, a tailor, and a storage company.

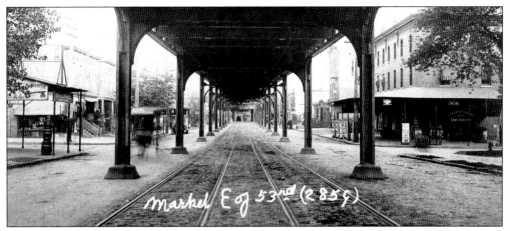

Market E of 53rd (2859)

During the construction of the elevated trains, the vertical girders had to be lowered from above rather than from the sides of the street lest they strike the overhead electric lines of the existing street-level trolleys and the nearby buildings. This 1908 photograph views Market Street, east of Fifty-third Street, as seen beneath the completed elevated railway.

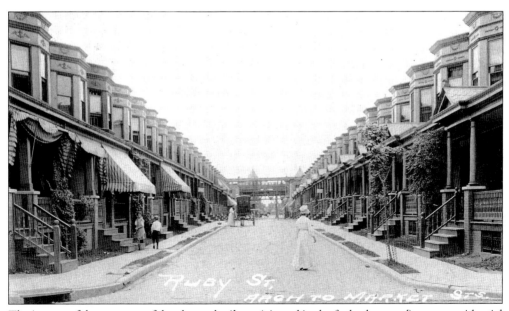

Ruby St. North to Market Sts.

The impact of the presence of the elevated railway (viewed in the far background) upon a residential street can be appreciated in this photograph. North Ruby Street is located between Fifty-third and Fifty-fourth Streets and Market and Arch Streets. The card is postmarked 1908.

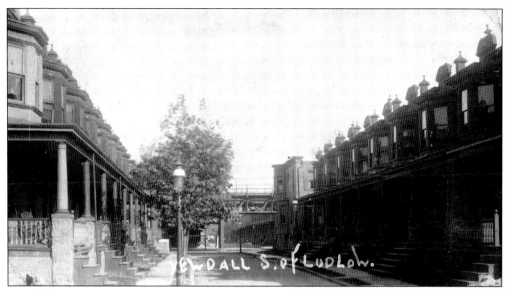

Yewdall and Ludlow Streets lie just southwest of Fifty-fourth and Market Streets and just west of Ruby Street, as seen in the preceding photograph. One can only imagine how this once-quiet street had been affected by the noise of the overhead trains.

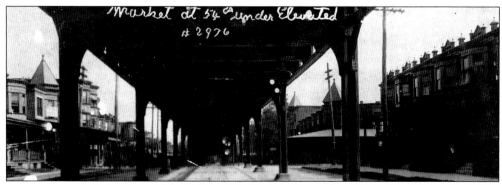

A 1908 panoramic view of Market Street, looking east from Fifty-fourth Street, shows the block beneath the tracks to be more residential than that of the photograph of Fifty-third and Market Streets, as seen on page 29.

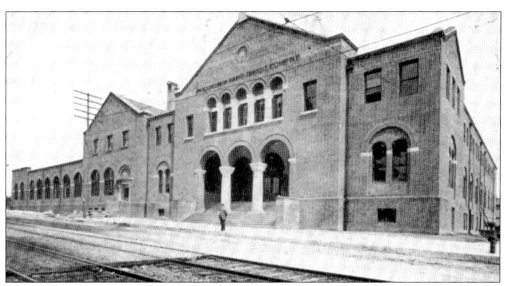

This was literally the end of the line for the Market Street elevated trains. The terminal building is seen just after its construction in 1907. The tracks of a trolley line running from West Chester Pike to Sixty-third Street are evident in the foreground.

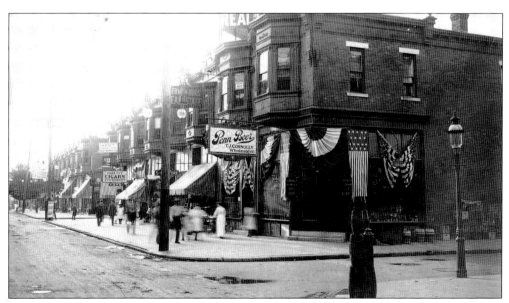

The reverse of this 1911 postcard states that this is a "Market Street Carnival Souvenir." T. J. Connolly's liquor store, on the north side of Market Street between Sixtieth and Sixty-first Streets, was ready for the occasion.

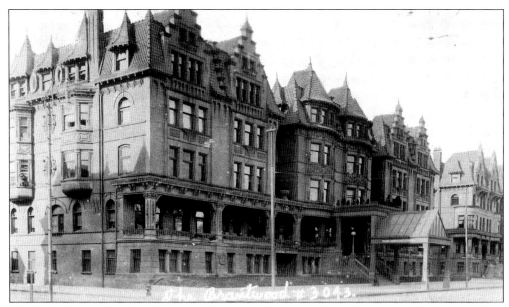

The Parkside neighborhood is named because of its proximity to Fairmount Park, situated on the west side of the Schuylkill River. The area blossomed during the time of the Philadelphia Centennial Exhibition of 1876. Many of the huge dwellings were utilized as boardinghouses and hotels during the centennial. A prime example was the Brantwood, located at 4130 Parkside Avenue, as seen in this 1909 view.

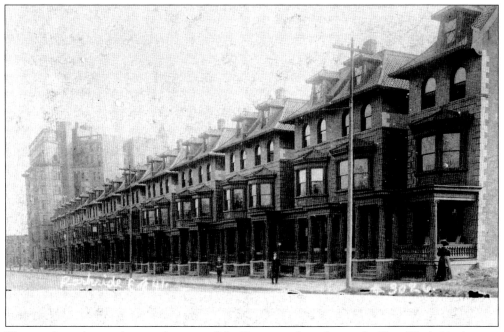

The stately, twin row homes, due east of the Brantwood on the south side of Parkside Avenue between Fortieth and Forty-first Streets, can be viewed in this 1907 photograph. The high-rise apartment building looming above the surrounding homes (far left, background) was the Parkside, located at the intersections of Fortieth Street and Parkside and Girard Avenues.

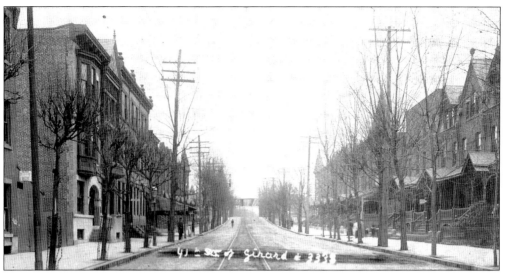

Forty-first Street south of Girard Avenue, also in the Parkside neighborhood, proudly displays its large three-story homes in this 1908 view.

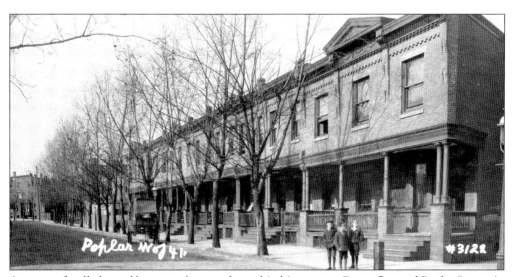

A group of well-dressed boys stands near a horse hitching post at Forty-first and Poplar Streets in this 1906 view. Although located only two blocks south of the Parkside apartments, these brick row homes were far more conservative in style and price than their Victorian neighbors.

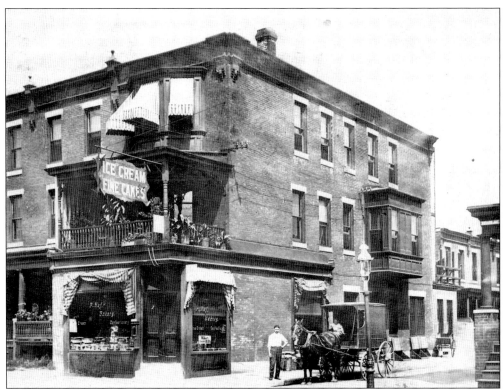

The Dunlap section of Philadelphia lies in the vicinity of Haverford Avenue and Market Streets between Forty-sixth and Fifty-second Streets. In 1907, Peter Huf's bakery was located at 5219 Girard Avenue. Ice cream was a delicacy introduced at the Philadelphia Centennial Exhibition of 1876 and became an extremely popular treat thereafter.

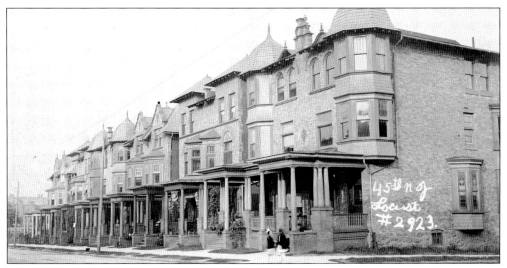

The limited boundaries of the Walnut Hill section extend from Forty-sixth to Fifty-second Streets and Market to Locust Streets. The neighborhood was built up between the dawn of the 20th century and the 1940s, although the homes at Forty-fifth and Locust Streets, seen in this 1908 view, appear to be more of the 20th century revival style.

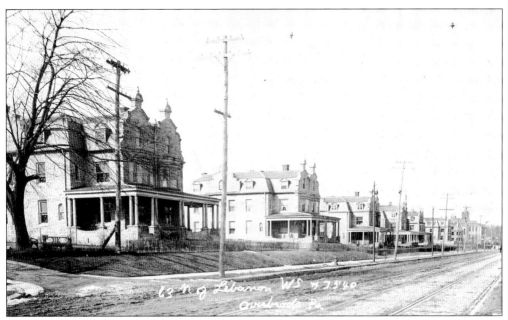

The Overbrook section begins at City Line and Lancaster Avenues, continuing southward toward Sixty-third Street. Sixty-third Street north of Lebanon Avenue was a poorly paved byway when this photograph was taken in 1907. The homes were of Victorian vintage and sat on large plots of land.

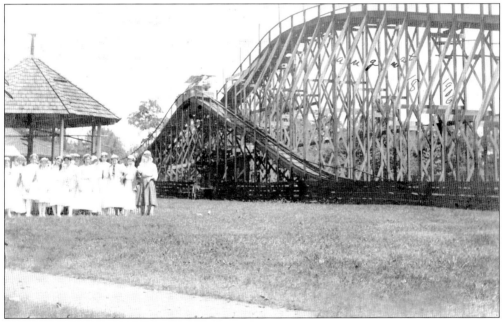

Woodside Park was an amusement park located in the area formerly known as Balwynne Park. A wonderful playland just outside of the city limits, it operated from 1897 to 1955. It was constructed by the Fairmount Park Transportation Company to increase its ridership. Seen here in 1908 is one of its many wooden roller coasters. The earliest roller coaster in the park, Thompson's Scenic Railway, was built in 1897.

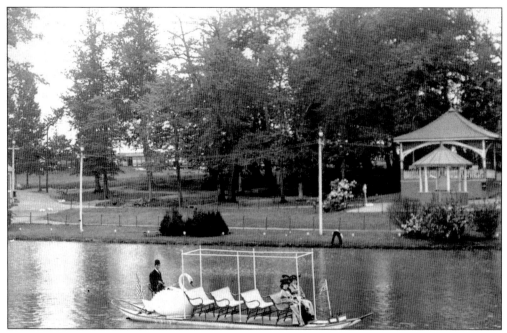

On many a lovely Sunday afternoon, young couples traveled by park trolley to Woodside Park and floated serenely about its lake on swan boats. The lake was bordered by a low granite wall. After the park closed in 1955, West Park Hospital was built on the site, and the wall remained to surround the hospital. This view is from 1911.

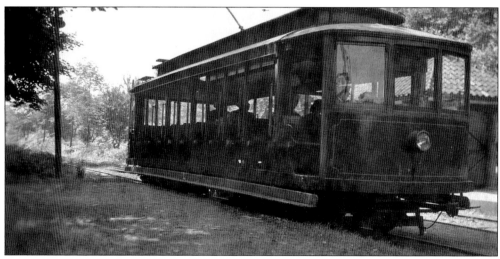

This open-air park trolley (No. 31) was in service in 1946. Built by the J. G. Brill Company, which was located at Thirty-first and Chestnut Streets, it is seen on its run through Fairmount Park to the Woodside Park terminus. When the Fairmount Park Transit Company ceased operation in 1946, nine miles of track, seven bridges, station buildings, and electrical equipment were put up for auction.

Two

Welcome to Southwest Philadelphia

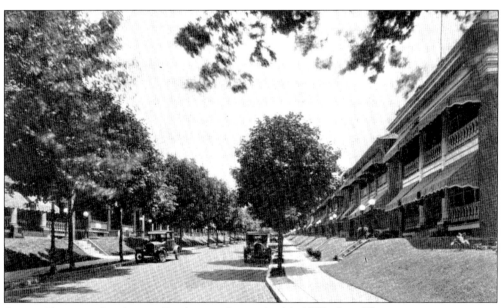

Angora Terrace, a lovely tree-lined street, is seen in this 1920 view. The exact cross streets are not mentioned on this card, but Angora Terrace is in the vicinity of Fifty-eighth Street and Baltimore Avenue. Although the Angora section was certified as blighted in 2005, Angora Terrace remains much more presentable today.

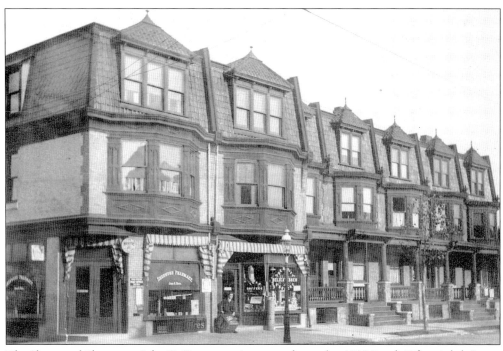

The Sherwood Pharmacy, John D. Burg proprietor, was located at 1323 South Fifty-eighth Street in the Angora section. On this postcard from 1911, a man relaxes in front of the delicatessen next door to the pharmacy.

St. Clements Roman Catholic church is seen in this 1904 postcard. It is still standing at Seventy-first Street and Woodland Avenue.

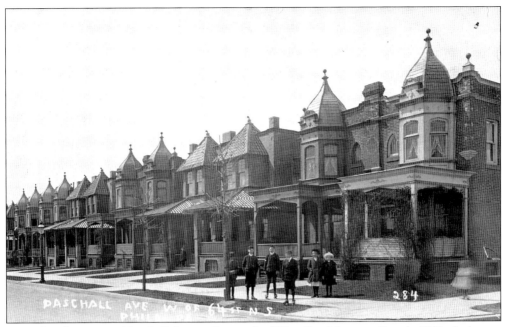

Sixty-fourth Street and Paschall Avenue lies south of Woodland Avenue. Seen in 1908, the homes sport majestic spires and beautifully tiled porch roofs.

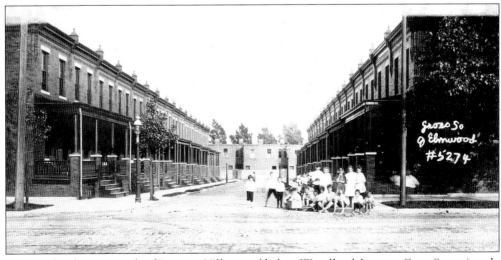

Elmwood is the area north of Bartram Village and below Woodland Avenue. Gross Street is only one block long and just off of Elmwood Avenue, between Sixty-third and Sixty-fourth Streets. The young trees seen on this card, postmarked 1909, indicate the newness of the street.

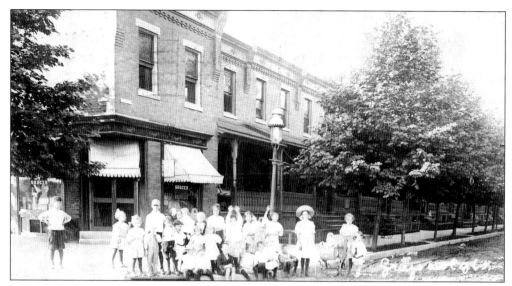

Grays Avenue at Sixty-third Street is only several blocks north of Gross Street. The presence of a large number of children most likely denotes that many younger families had moved here. The postcard is from 1908.

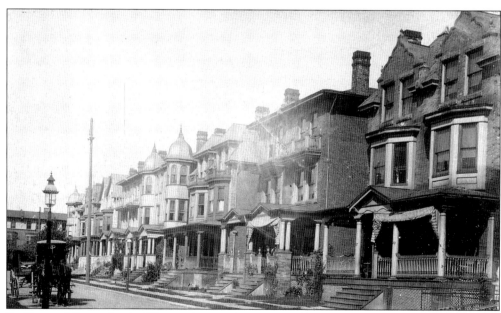

St. Bernard Street in the Kingsessing section is a small development sandwiched between Warrington and Chester Avenues, just west of Forty-ninth Street. The street's dead end at Warrington Avenue is just visible in the far left background. This view is from 1908. Kingsessing is a Native American term for "place where there is a meadow."

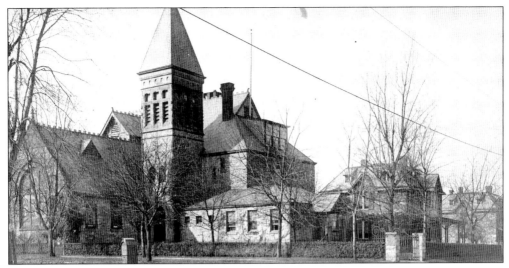

The stately Presbyterian Orphanage is located at Fifty-eighth Street and Kingsessing Avenue. The architects and engineers, Wilson Brothers and Company, were in business from 1876 until 1902. This postcard is from around 1904. The building remains on the Philadelphia Architects and Buildings Project Web site.

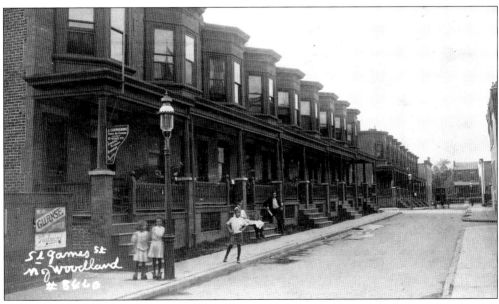

J. Carmignano was a dry cleaner who worked out of his home on St. James Street, near Sixty-sixth Street and Woodland Avenue. One would never be able to locate St. James Street in a current Philadelphia directory, since the name was changed to Shields Street after this 1911 photograph was taken.

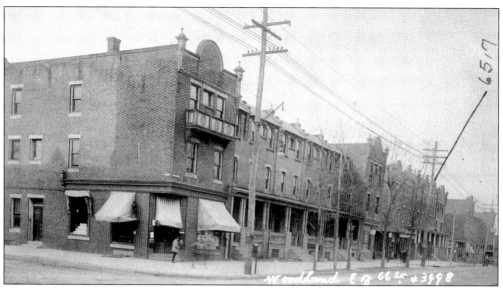

The reverse of this postcard from 1910 states that Dr. Cosmo S. W. Schomo's dental office was located at 6517 Woodland Avenue (highlighted in ink by the writer on the illustrated side of the card). This was a block away from St. James Street, and perhaps the Carmignanos were his patients.

Forty-eighth Street and Warrington Avenue is a placid, medium-sized street, as seen in this 1908 photograph. Large area front–bay windows and shade trees made for many a relatively comfortable summer evening.

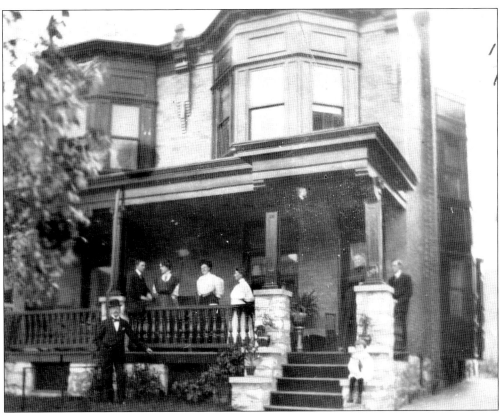

A family attempts a candid shot in front of their home at 1204 South Wilton Street in 1908. This address is just west of Fifty-second and Springfield Avenue in the Kingsessing section.

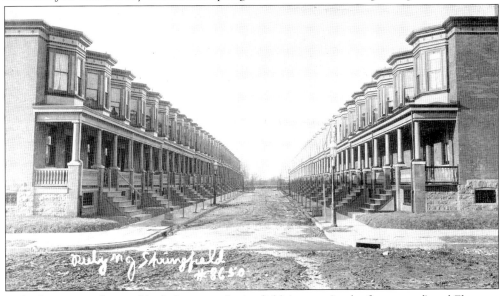

Ruby Street runs for two blocks between Springfield Avenue (in the foreground) and Florence Avenue, west of Fifty-third Street. The postcard, dated March 1911, reads, "These are all new houses and are very nice inside." Springfield Avenue remained as yet unpaved.

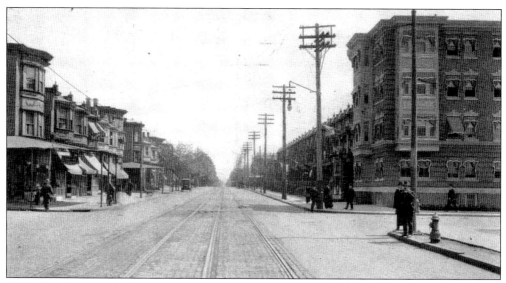

Fifth-sixth Street and Chester Avenue was a mature community, replete with a fine apartment house and local shops, when this photograph was taken in 1920. One of the important West Philadelphia trolley routes ran along Chester Avenue.

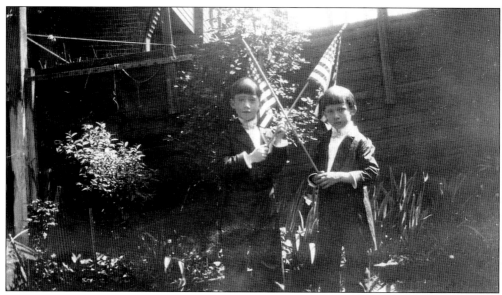

The reverse of this delightful postcard reads "Clinton (age 6) and Hubert (age 5), 5736 Belmar Terrace. Taken in a 'Tom Thumb Wedding' on Hubert's birthday May 27, 1911." Belmar Terrace is a small court north of Fifty-seventh Street and Springfield Avenue.

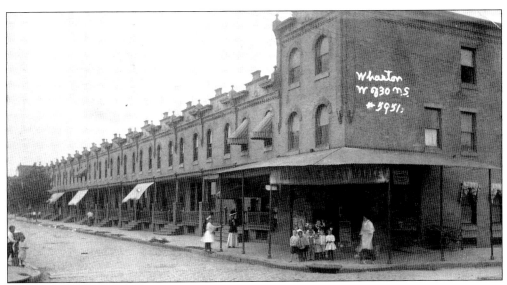

Harry K. Robinson owned a meat market at 3001 Wharton Street in the Grays Ferry section. It is seen in this 1908 view.

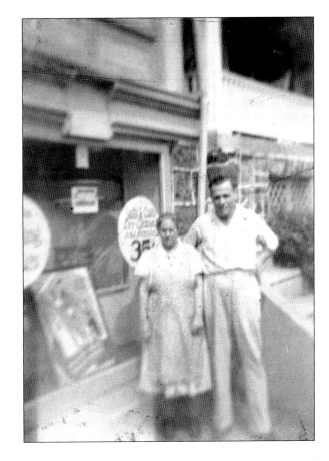

Only several blocks away, but 32 years later, the author's grandparents, Anna and Hyman Spector, pose in front of their dry cleaning shop on the corner of Thirty-first and Dickinson Streets. Like most mom-and-pop establishments, they lived above the store.

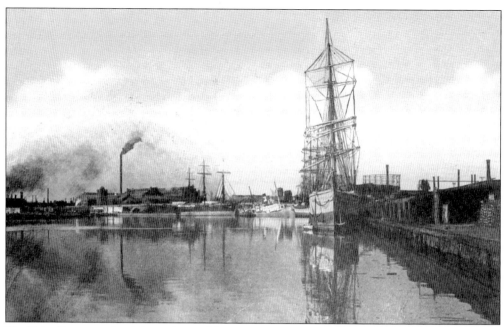

The Point Breeze section is located east of the Schuylkill River, north of Passyunk Avenue, and south of Grays Ferry Avenue. This is a 1905 view of the oil works in this heavily industrialized area.

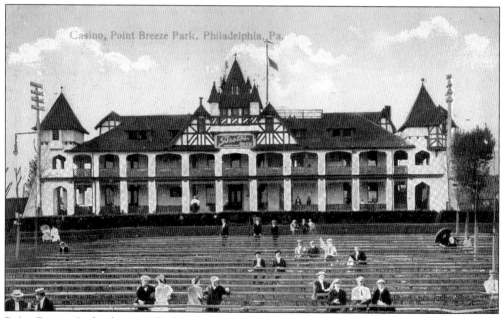

Point Breeze Park, the site of a former Civil War soldiers' camp, was located at Twenty-sixth Street and Penrose Avenue. Annie Oakley reported having lost a shooting match there in 1887. A racetrack was listed as one of its early attractions. Illustrated here is the casino building as seen in 1914.

Three

THE MANY FACES OF NORTH PHILADELPHIA

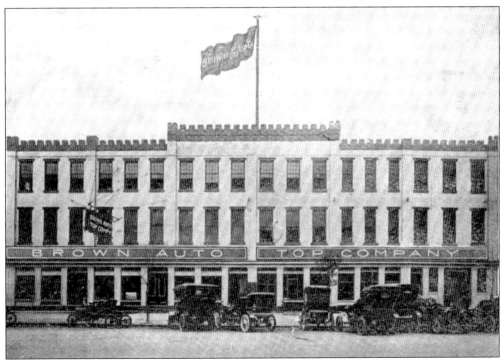

The Brown Auto Top Company was located at Broad and Hamilton Streets in this 1907 view. Their motto was, "We are growing—there's a reason." The reason for their growth was most certainly the unprecedented expansion of the automobile industry. During this period, Broad Street north of city hall was home to many car dealerships, tire distributors, and businesses selling various automobile paraphernalia.

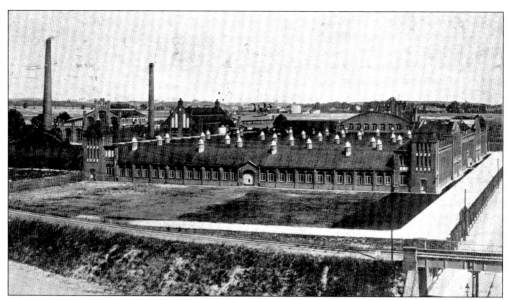

The Hess-Bright Ball Bearing Company was the nation's largest manufacturer of annular ball bearings when this photograph was taken in 1909. Located at Nineteenth and Hamilton Streets, the main shops are most visible toward the front of the postcard. In the background are the storehouse, hardening house, powerhouse, and garage.

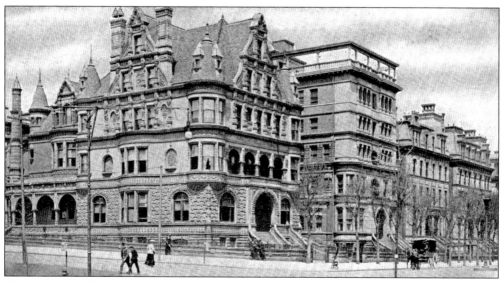

The Josephine Widener Memorial Library, originally the Widener mansion, was located on the northwest corner of Broad Street and Girard Avenue, as seen in this 1905 postcard. The mansion was designed by architect Horace Trumbauer. It opened as a library in 1900.

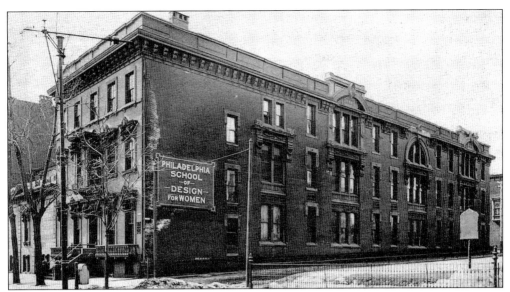

The Philadelphia School of Design for Women was located at Broad and Master Streets. The Broad Street end of the building and its adjoining picture gallery was the former home of the famous Shakespearean actor Edwin Forrest. It is seen here in 1903.

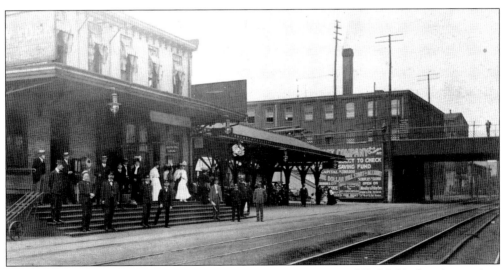

The Philadelphia and Reading Railroad transported passengers into Philadelphia from its terminus in suburban Chestnut Hill. Well-dressed patrons and railroad employees await the arrival of the train at the Columbia Avenue station, as seen in this 1908 view.

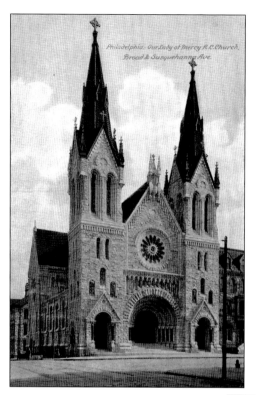

Our Lady of Mercy Roman Catholic Church, an imposing granite church with lofty twin steeples, was located at Broad Street and Susquehanna Avenue, as see here in 1908. The parish, dedicated in 1893, was located in a heavily populated Irish neighborhood. The pastor, Monsignor Drumgoogle, was instrumental in teaching Irish history to the children of the parish school.

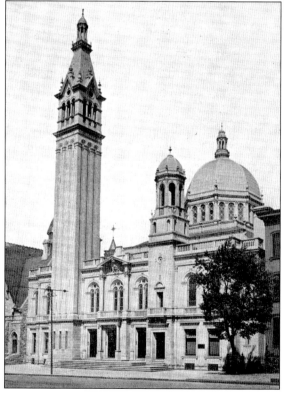

Keneseth Israel synagogue was located on Broad Street above Columbia Avenue. Dedicated in 1892, it included two distinctive architectural features, including its campanile, which was modeled after St. Marks' Square in Venice, Italy, and the dome, which was after that of the Mosque of Omar in Jerusalem. This is a 1905 view showing both of its architectural attributes.

The National Philatelic Museum was located at Broad and Diamond Streets from the 1940s into the 1960s. At the time, it was the only museum of its kind in the world dedicated to furthering the interests of philately. This view is from 1947. The property is now on the Temple University campus.

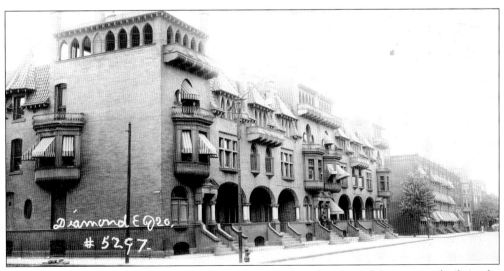

The fashionable grouping of brick homes at Twentieth and Diamond Streets was built in the Spanish style. The house on the corner has an interesting enclosed fourth floor rooftop. This card is from 1906.

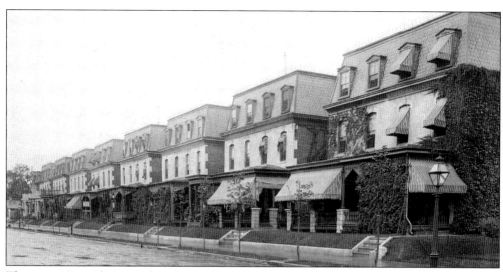

The neat twin residences in this photograph from about 1907 are located on Hunting Park Avenue west of Twenty-second Street. These two streets also intersect with West Erie Avenue. Sapling trees line the manicured sidewalks, indicating the recent development of this street.

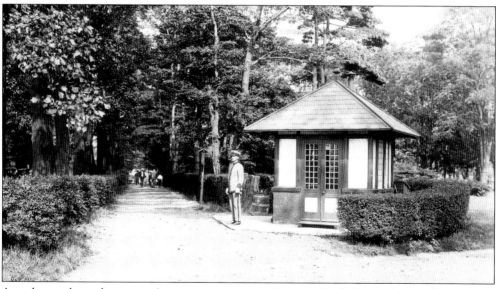

A park guard stands at attention at an entrance to Hunting Park, located at York Road and Hunting Park Avenue, as seen in this 1923 postcard. His guardhouse was typical of those planted throughout the city. Under the auspices of the Fairmount Park Commission, Hunting Park advertised 71 acres of shaded trees, a children's playground, plenty of benches, good water, and no danger spots. The area now experiences a high crime rate.

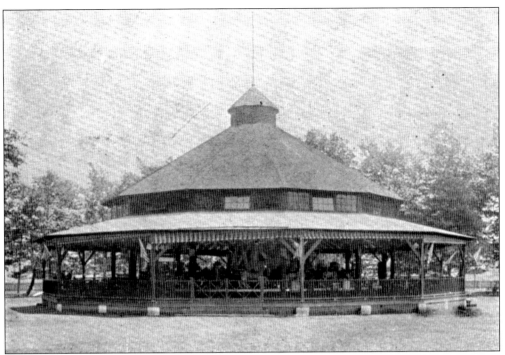

The new merry-go-round building at Huntingdon Park is displayed in this 1915 view. Band concerts were heard on Saturday afternoons and evenings in the nearby bandstand, and some were supposedly conducted by John Philip Sousa. The park was also the site of a minor-league baseball team.

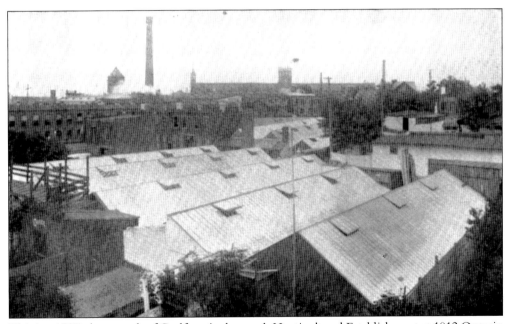

This is a 1907 photograph of Godfrey Aschmann's Horticultural Establishment at 1012 Ontario Street. The rooftop view provides an inkling of the diverse makeup of the neighborhood.

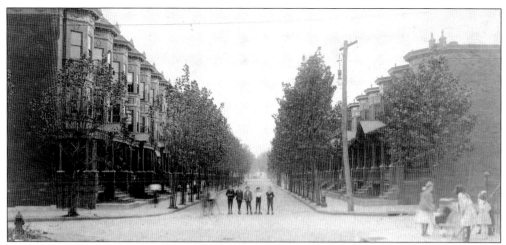

The Franklinville area of Philadelphia is defined as a triangle bounded by West Sedgley Avenue north Broad Street and West Hunting Park Avenue. The intersection of Eleventh and Venango Streets, not far from the Samaritan (Temple) Hospital, appears to be a child-friendly area in 1906.

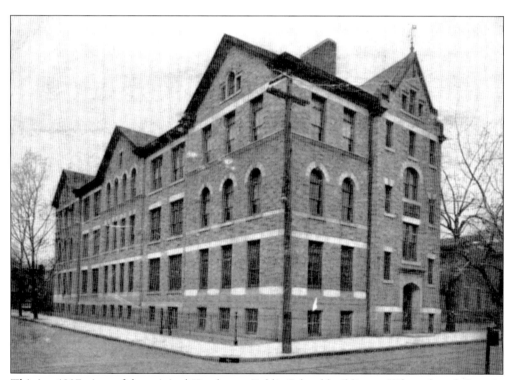

This is a 1907 view of the original Kenderton Public School building at Fifteenth and Ontario Streets. The present school structure is of a somewhat more modern vintage.

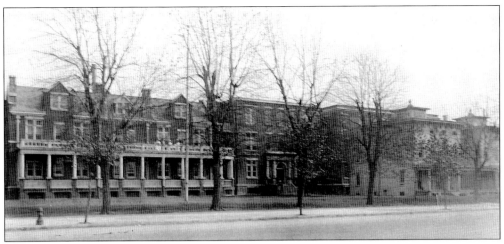

The Samaritan Hospital was integral to the growth of North Philadelphia. Founded by Rev. Russell Conwell in 1892 and located at Broad and Ontario Streets, it initially opened as a large double house with 14 rooms, as seen in this 1904 view. During the first six months of its service, 17 operations were recorded as being performed, and 87 patients admitted.

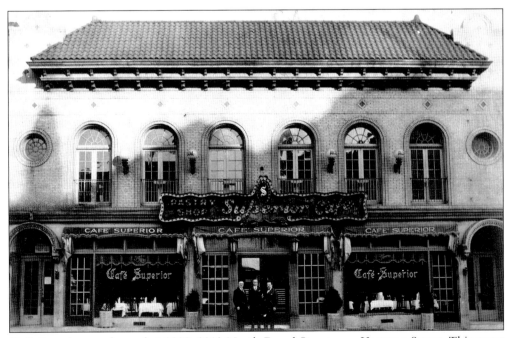

Café Superior was located at 3809–3813 North Broad Street near Venango Street. This scene was captured around the 1920s.

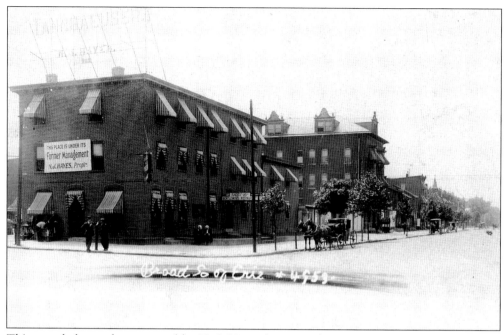

This upscale beer saloon, owned by N. J. Hayes (its sign advertising that it is again under his proprietorship), is seen in this 1905 view taken on Broad Street south of Erie Avenue. Note the elegant carriage waiting at the corner.

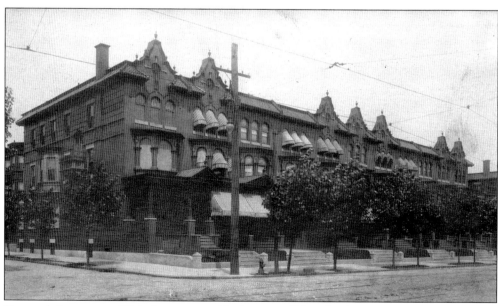

Sixteenth Street east of Erie Avenue, two blocks west of Hayes's saloon, is captured in this 1905 photograph. Awnings, in this pre–air conditioner era, were quite the rage.

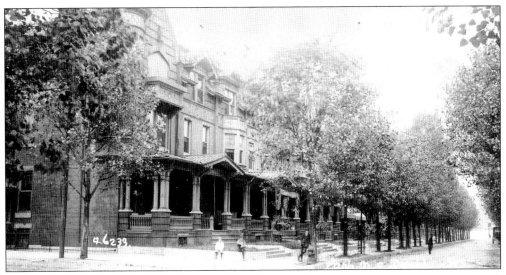

The 2300 block of North Park Avenue was due east of Broad and Dauphin Streets. This card, postmarked 1908, shows the small tree-lined street with its open-air porches.

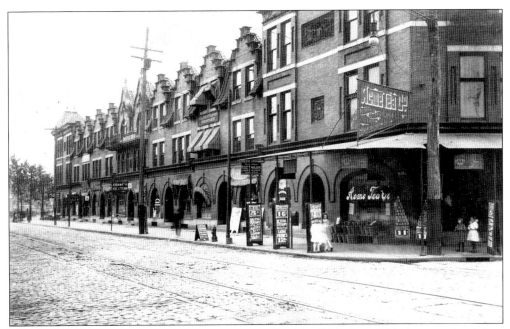

Germantown Avenue and Butler Street are seen in this 1906 view. This intersection is just northwest of the point where Germantown Avenue crosses Broad Street. The Acme Tea Company was founded in 1887 and merged with the American Stores Company in 1917. By 1913, there were 201 Acme stores in Philadelphia.

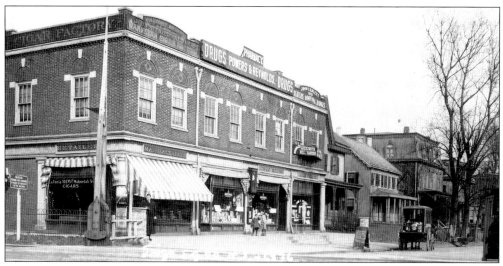

Gopsill's Philadelphia Business Directory for 1907 listed 17 pages of cigar dealers and makers throughout the city. Manufacturers ranged from mom-and-pop storefronts to large factories, producing huge volumes of cigars each year. One such smaller concern was John Steigerwald and Company, located at 1937 Tioga Street. It is viewed here in 1906.

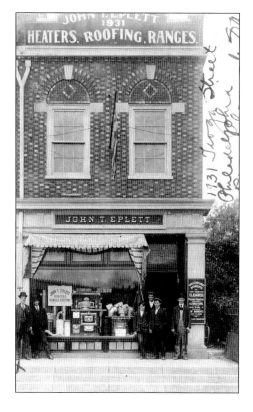

The John Eplett Company can be seen in the preceding illustration situated next to the Powers and Reynolds pharmacy. It appears here in this 1907 postcard.

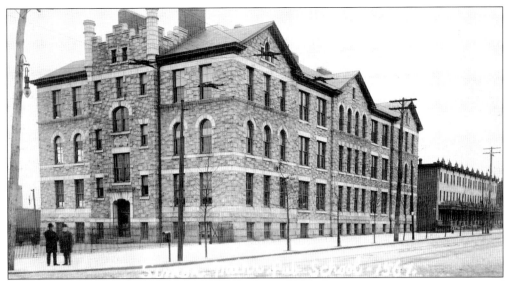

The Simon Muhr Public School, located at Twelfth Street and Allegheny Avenue, is viewed here in 1905. Muhr, born in Bavaria in 1845, immigrated to America at the age of eight. In the 1880s, he was well known for his philanthropic contributions to the Jewish community.

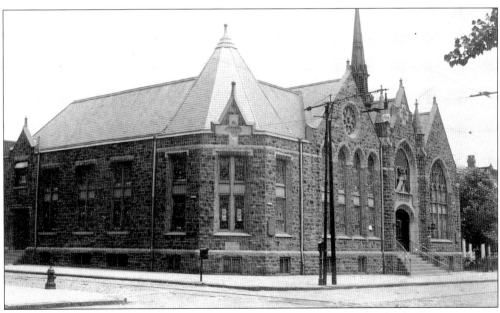

The Lehigh Avenue Baptist Church, located at Twelfth Street and Lehigh Avenue, was an impressive granite edifice in 1905.

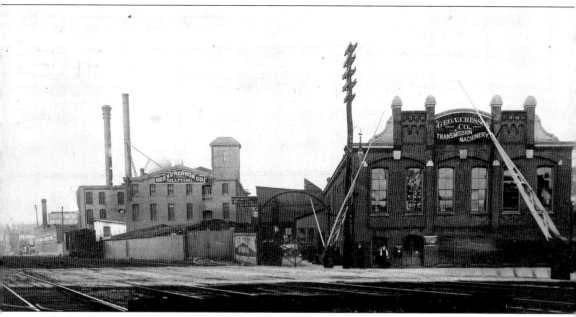

The George V. Cresson Company was located on a six-acre property at Eighteenth Street and Allegheny Avenue. This 1906 scene shows a portion of the company that produced power transmitting machinery, such as shafting, rock breaking, and concentrating equipment. Cresson's was a huge employer in this Allegheny West section of the city.

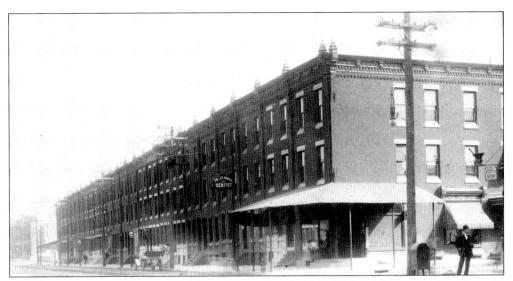

Lehigh Avenue east of Twenty-sixth Street is seen here in 1905. Philadelphia Rapid Transit ran its electric cars along the former Lehigh Avenue Railway lines in this working-class neighborhood. The gentleman on the corner is probably waiting for a trolley.

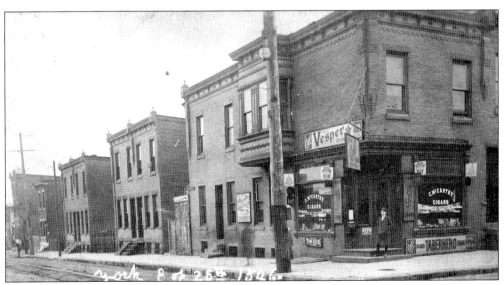

McCarthy's Cigar Store was situated at the corner of York and Twenty-fifth Streets in this 1905 view.

The houses on the south side of the 2200 block of Cumberland Street were new in this photograph dated September 1907. The postcard's sender had purchased the home at number 2226.

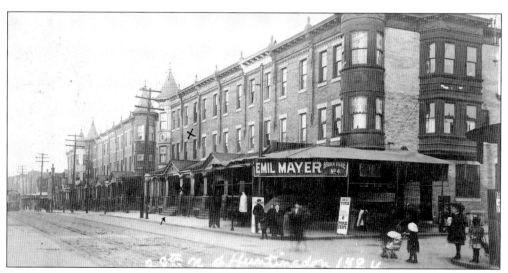

Strawberry Mansion's boundaries were Thirty-third Street to the west, Twenty-ninth Street to the east, Lehigh Avenue to the north, and Oxford Street to the south. The photograph shows the intersection of Twenty-ninth and Huntingdon Streets, which was an area predominantly populated by immigrants of German origin. Emil Mayer was listed in 1907 as having four butcher shops in the general vicinity of Strawberry Mansion.

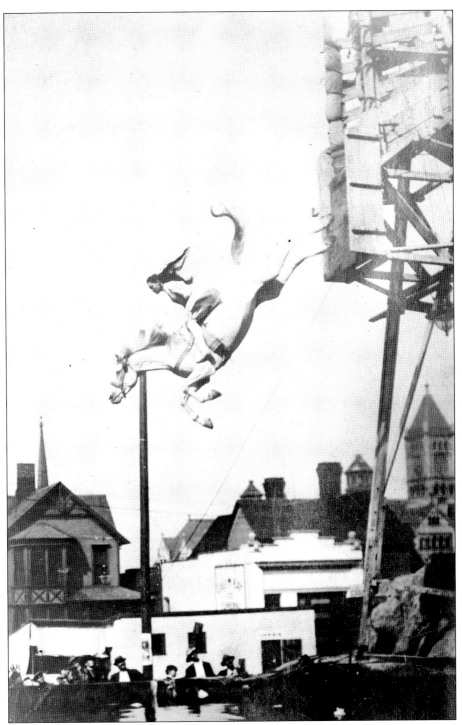

Anyone might have expected to see a diving horse at Steel Pier in old Atlantic City. But no one would have imagined a hippodrome just within the boundaries of Strawberry Mansion. This photograph was taken at Twenty-ninth Street and Columbia Avenue in April 1909. Curious onlookers are about to be drenched.

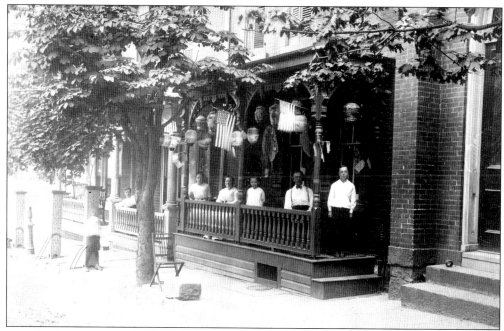

This family's porch is bedecked with flags and Chinese lanterns for the July 4, 1908, holiday. Their address at 2548 (now North) Myrtlewood Street is just west of Twenty-ninth and Cumberland Streets.

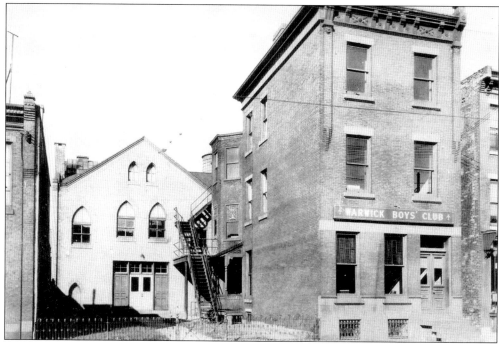

The Warwick Boys' Clubhouse and Gym was located at 2240–2244 North Twenty-ninth Street near Dauphin Street. This 1905 advertising postcard states, "600 boys can work and play here when fully equipped. Which shall it be? On the street corners shooting craps or in an atmosphere like this? We must raise funds at once or quit."

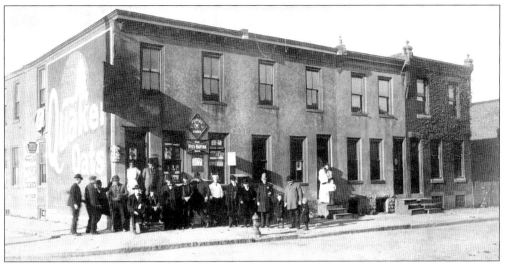

The Nicetown-Tioga section is bounded by Wingohocking Street to the northeast, Roberts Avenue to the northwest, Wissahickon Avenue to the west, Broad Street and Hunting Park to the east, and Allegheny Avenue to the south. A group of neighbors, including the local friendly policeman, have gathered for a group picture in 1906. The site is James Nagle's grocery, located on the corner of Bristol and Clarissa Streets.

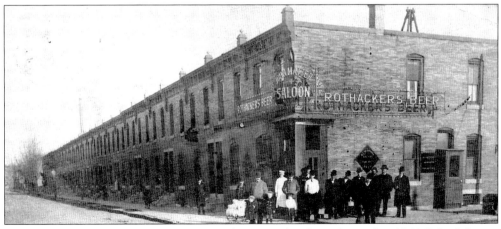

Just across from the Nagle grocery was John Matter's saloon, located at 1954 Bristol Street. According to *Gopsill's Business Directory* for 1905, Matter lived next door at 1952 Bristol Street.

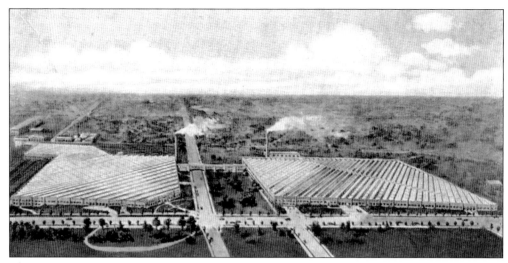

The Atwater Kent Company, seen in its Nicetown location in 1927, was located at Abbottsford Road and Wissahickon Avenue and was the world's largest producer of radios. After the Depression began in 1929, organized labor forced changes in the company's policies, and the business was closed in 1935.

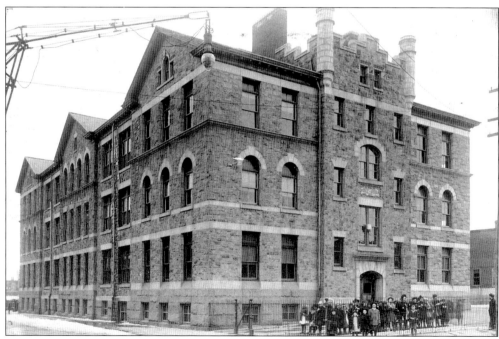

The Edward Steel Public School was located at Sixteenth and Cayuga Streets in the Nicetown section. A group of students stand in front of the main entrance to the building in this 1907 photograph.

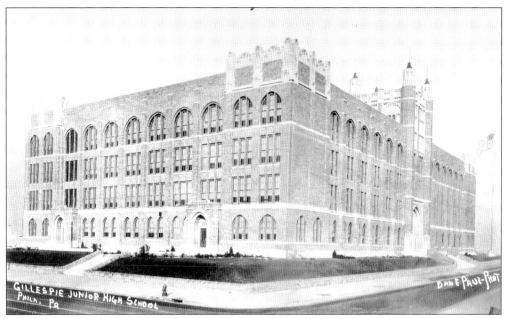

The Elizabeth Gillespie Junior High School is still located at Eighteenth and Pike Streets in the Nicetown area. The huge campus is seen in this view from about 1928. The school has been renamed Gillespie Middle School. It is currently listed as one of the dangerous schools in Philadelphia.

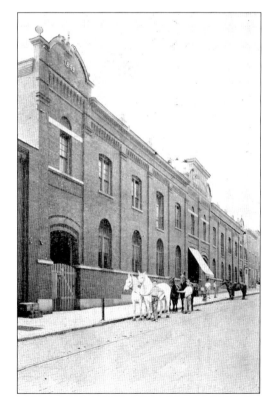

The stables of the Louis Bergdoll Brewing Company, designed by architect Otto Wolf, are shown in this 1907 postcard. Located at Twenty-ninth and Parrish Streets, the Bergdoll Company commenced beer production in 1849. One of the perquisites afforded its employees was a free, daily beer break. The pure artesian well water of Brewerytown added to its taste appeal. Bergdoll existed throughout Prohibition until 1934. The building complex was developed into condominiums in the 1980s.

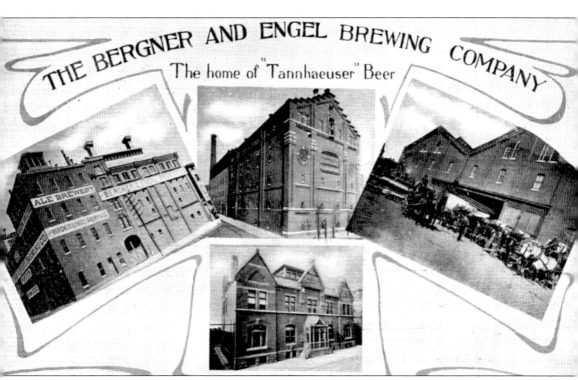

Brewerytown was an industrial neighborhood on the east bank of the Schuylkill River north of Fairmount Avenue. It consisted of 10 blocks of major and minor breweries, German bakeries, and delicatessens and was populated with brewmasters and hundreds of plant workers. By the end of the 19th century, the Bergner and Engel Brewing Company, located at Thirty-second and Master Streets, was one of the largest brewers in the United States, producing one quarter million barrels per year. This 1906 postcard reveals various aspects of the 10.5-acre plant.

Four

OAK LANE, LOGAN, AND OLNEY

East Oak Lane is the area that lies between Godfrey and Cheltenham Avenues east of Broad Street. This 1919 card shows a new development of identical single homes on Broad Street south of Haines Street.

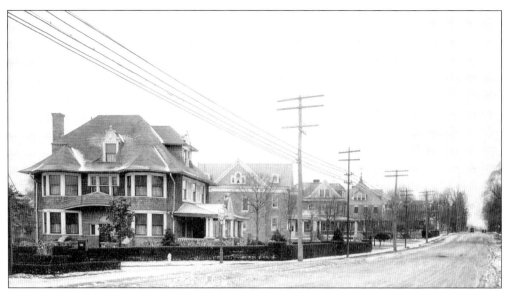

York Road, a long, winding thoroughfare of great historical significance, begins in North Philadelphia and ends in Montgomery County. This photograph from about 1911 shows a portion of York Road as it winds its way through the East Oak Lane section. The byway is rutted and has yet to be paved.

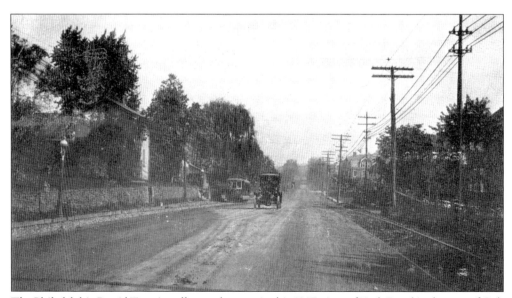

The Philadelphia Rapid Transit trolley tracks, seen in this 1907 view of York Road in the area of Oak Lane, were utilized to transport passengers between Philadelphia and Willow Grove Park.

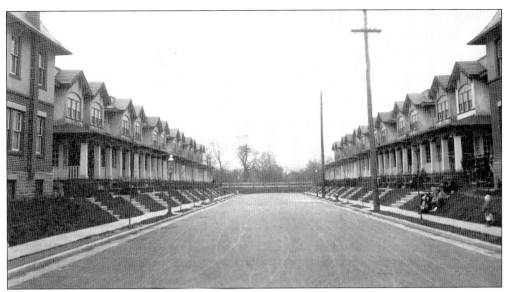

West Oak Lane's boundaries are east Mount Airy, Cheltenham Avenue to the north, and East Oak Lane. A newly planted Fifteenth Street, south of Sixty-eighth Avenue, is viewed in this 1910 postcard. The street becomes a dead end at Northwood Cemetery, which is seen in the far background.

The single homes on Sixty-eighth Avenue east of Thirteenth Street were of the Tudor style. The card is postmarked 1911.

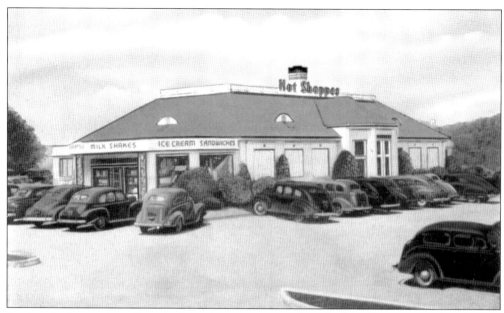

During the happy days of youth, drive-in restaurants such as the Hot Shoppe were the places to be seen on Saturday night dates. Although this is a generic 1930s postcard, it typifies the exterior of the landmark that was located at Stenton Avenue and Broad Street. The first Hot Shoppe was opened by J. Willard Marriott in 1927 in suburban Washington, D.C.

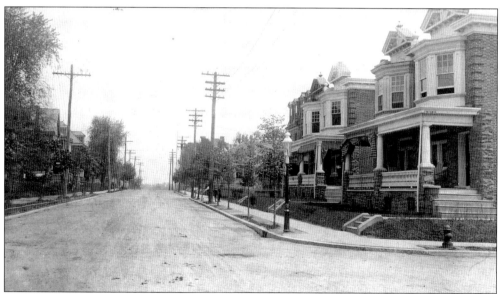

The Logan section of Philadelphia is bounded by Wingohocking Street to the south, Sixteenth Street and Lindley Avenue (Wakefield Park) to the west, Olney Avenue to the north, and an area near North Seventh Street and West Fisher Avenue to the east. The card, postmarked in 1910, shows Lindley Avenue east of Eleventh Street as a quiet, tree-lined thoroughfare.

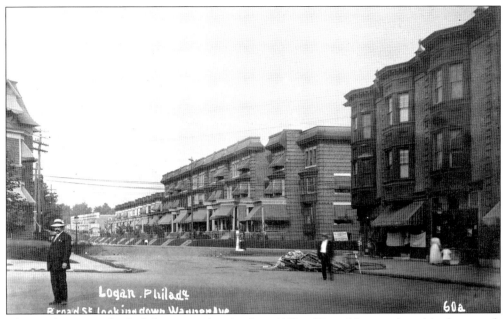

The gentleman on the far left was standing in the middle of Broad Street when this photograph was snapped in 1910. New homes on Wagner Avenue can be seen in the background on the east side of Broad Street.

This advertising postcard from 1910 shows Morris Gibbs's grocery and meat store at 1335 Rockland Street, located in the Logan section. Like so many similar small businesses, the Gibbs family probably lived in the home behind their store.

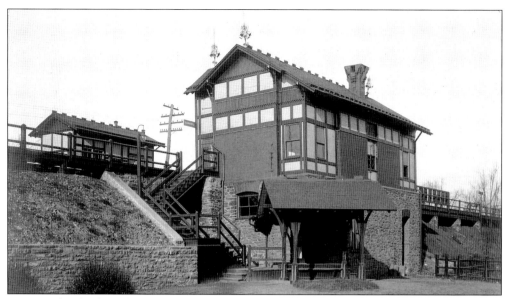

In 1905, the climb to the Logan station of the Philadelphia and Reading Railroad was neither for the handicapped nor the faint of heart.

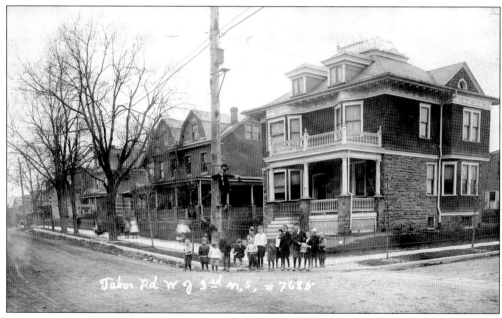

Tabor Rd W g 3rd m s. #7685

The Olney section ranges from Roosevelt Boulevard on the south, Godfrey Avenue to the north, Tookany Creek to the east, and a railroad right-of-way west of Sixth Street to the west. In the late 19th century, Olney thrived by virtue of major industries that were attracted to the area. This 1907 scene is located in Olney's residential section at Tabor Road, looking west from Third Street.

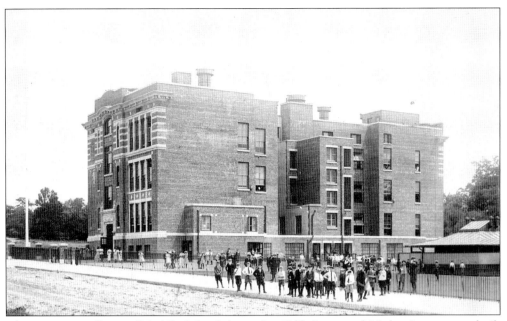

The James Russell Lowell Public School, located at Fifth Street and Nedro Avenue, was built in 1913. This is a view of the school shortly after it opened.

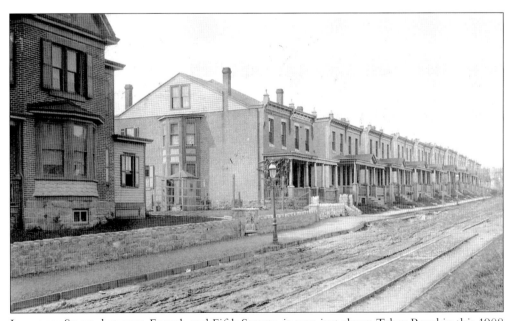

Lawrence Street, between Fourth and Fifth Streets, is seen just above Tabor Road in this 1908 view. The homes on the west (left) side of the street were newly built. The roadway had yet to be finished.

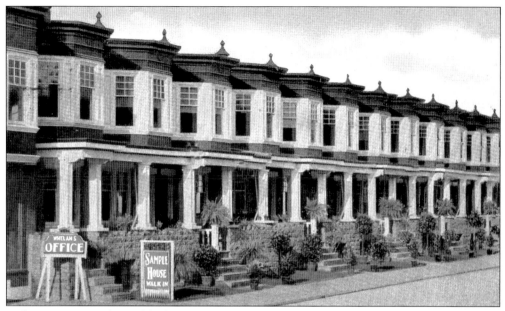

Rubicam Street, only one block long, is located between Second and Third Streets and Lindley and Duncannon Avenues. Whelan Builders advertised these attractive row homes in 1917.

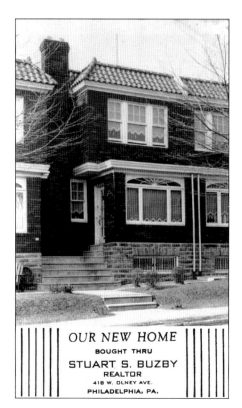

Postcards were a powerful, inexpensive means for realtors to advertise the homes that they had placed for sale. This home located in the Olney section was sold in 1907.

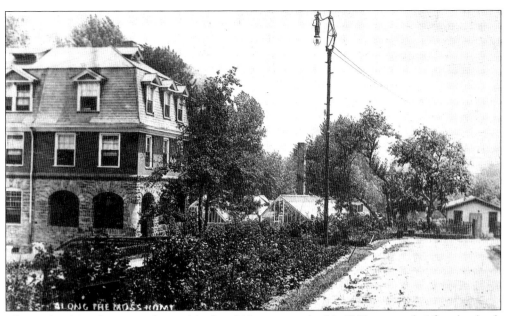

The Lucien Moss home was located in the old house seen in this 1908 postcard. After the death of Moss's wife in 1907, his estate was directed to erect the Home for Incurables near York and Tabor Roads. The Moss rehabilitation facilities, now a huge complex, are currently located at this site.

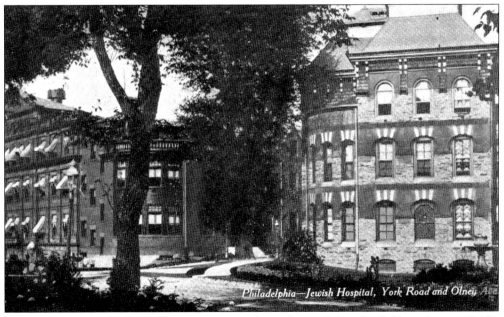

The Jewish Hospital, seen in this 1911 view, was located at York Road and Olney Avenue. In the early 1880s, the original site was called the Home for Aged and Infirm Poor Israelites. Within the next 10 years, the Jewish Hospital building was constructed. Throughout the 20th century, the campus was altered and upgraded. In 1951, the complex was renamed the Albert Einstein Medical Center.

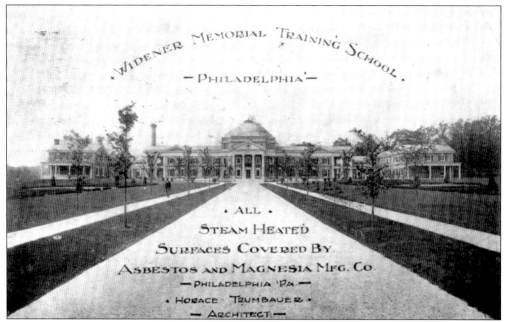

On April 14, 1912, the RMS *Titanic* was lost at sea. Among its victims were George W. Widener and his son Harry Elkins Widener. One month later, P. A. B. Widener, George's father, gifted $4 million to the Widener Memorial School for Crippled Children. The school, actually founded in 1906, is located at Broad Street and Olney Avenue, as seen in this 1908 view.

Olney High School, located on West Duncannon Street, graduated its first class in 1931. At one time, the school was said to have had the highest enrollment in the city. This postcard is dated 1949.

Five

FAIRMOUNT AND
SPRING GARDEN

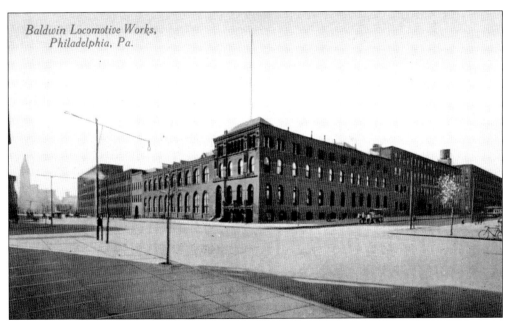

Baldwin Locomotive Works,
Philadelphia, Pa.

Matthias W. Baldwin, founder of the Baldwin Locomotive Works, was a jeweler and silversmith with a great interest in steam engines. His first locomotive, *Old Ironsides*, was put into service in 1832. His original plant was a sprawling complex, located on Spring Garden Street, east of Broad Street. Some vestiges of its buildings still remain.

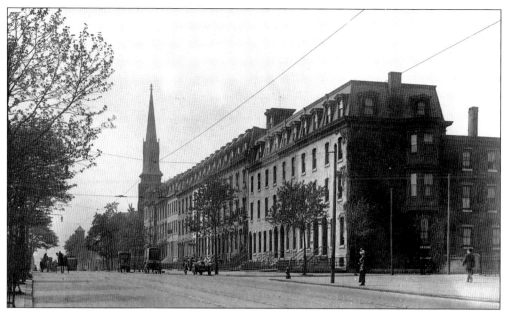

Spring Garden Street, west of Seventeenth Street, is seen in this 1908 photograph. Many of the stately homes were owned by wealthy professionals who lived and worked in Philadelphia.

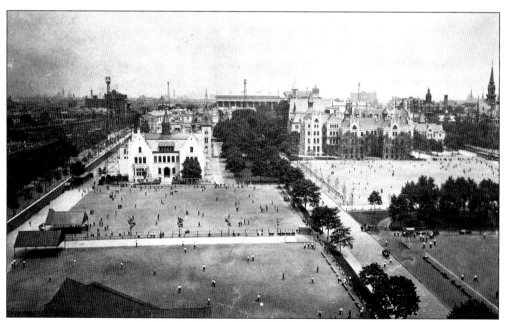

Girard College, seen in this 1902 bird's-eye view, was founded in 1831 by Stephen Girard, who was himself an orphan. According to his will, he created an institution to educate poor, fatherless white boys. Its Founders Hall is a prime example of Greek Revival architecture. The campus is located between Nineteenth and Twenty-fifth Streets on Girard Avenue.

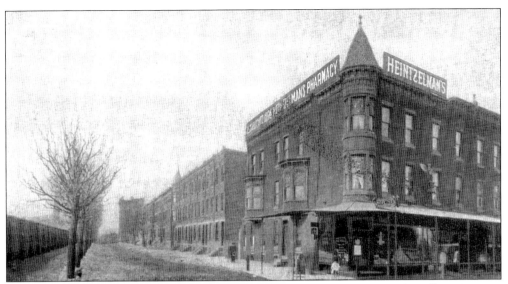

Joseph Heintzelman was a druggist located at the corner of Ridge and North College Avenues in 1905. On the far left is the northern retaining wall of Girard College.

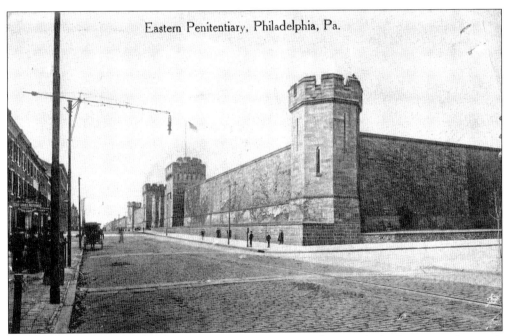

The Eastern State Penitentiary is seen in this 1913 view along with the homes on the south side of the 2100 block of Fairmount Avenue. The prison, opened in 1829, was created with the express intent of reforming criminals rather than punishing them. After visiting the prison, Charles Dickens wrote that the concept had failed deplorably, since many prisoners were in deep despair or had become insane.

This photograph of Sixteenth and Green Streets was taken in 1909. The row homes, erected in the 1850s and 1860s, were quite large. Although built in the conservative style of the time, many were occupied by middle managers of the Baldwin Locomotive Works. One hundred years later, the area fell into disrepair. However, it has experienced a renaissance, with the huge homes being renovated into multiple apartments.

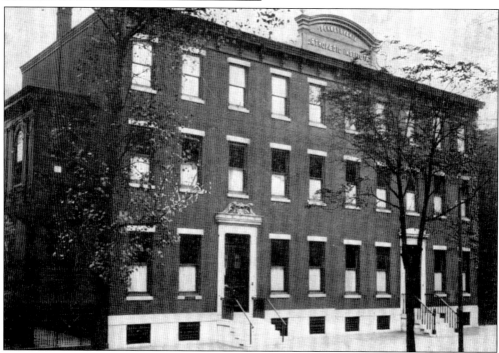

Postmarked in 1913, this card shows the Pennsylvania Orthopedic Institute and School of Mechano-Therapy, located at 1709 and 1711 Green Street. This view better illustrates the typical houses found on Green Street. The buildings are 130 feet deep, and each home is 50 feet across.

Six

GERMANTOWN AND MOUNT AIRY

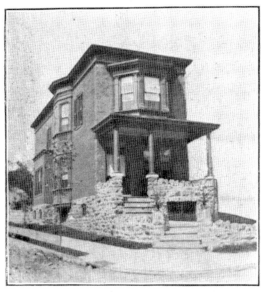

The House You Will Eventually Buy

Henry W. Bauer, Builder
Walnut Lane, Morton and High Streets
GERMANTOWN
Large Lots : Terrace Fronts : Side Yards
Modern Design : : : Hardwood Finish

Germantown is a neighborhood in northwest Philadelphia. Its approximate borders are Wissahickon Avenue, Roberts Avenue, Wister Street, Stenton Avenue, and Washington Lane. This "lovely" home, found on an 1890s advertising card, was located southwest of Chew Avenue and Washington Lane and most certainly was the new house that "you will eventually buy."

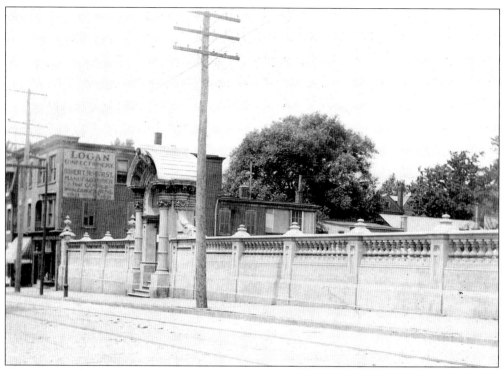

The reverse of this 1907 postcard states that this is the site of the lower burial ground where Gen. James Agnew and other British soldiers were interred after having been killed in the Battle of Germantown in 1777. The cemetery was located in the 4900 block of Germantown Avenue near East Logan Street.

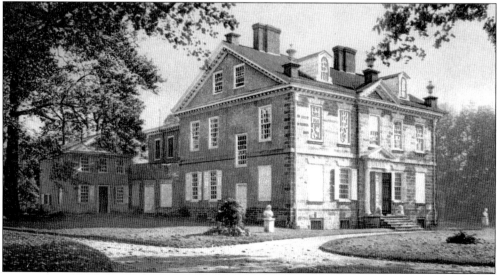

Cliveden, built in 1763 by Benjamin Chew, was an elegant mansion constructed in the Georgian style. During the Revolutionary War, the home was occupied by the British. In October 1777, George Washington was defeated at the Battle of Germantown, and there are still bullet marks on its outer walls. Cliveden, at 6401 Germantown Avenue, was donated to the National Trust for Historic Preservation in 1972 by the Chew family.

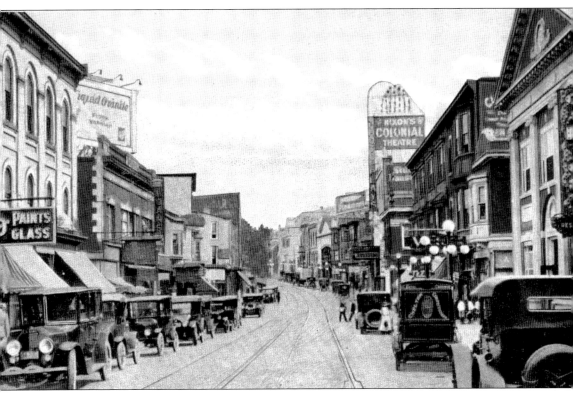

Germantown Avenue near School House Lane was a thriving, crowded business district in the 1920s. It was a rather wealthy area, as evidenced by the number of suave automobiles parked along the curbs. Nixon's Colonial Theater in the 5500 block of Germantown Avenue can be recognized by its huge rooftop sign. The theater was built in 1913 and demolished in 1960.

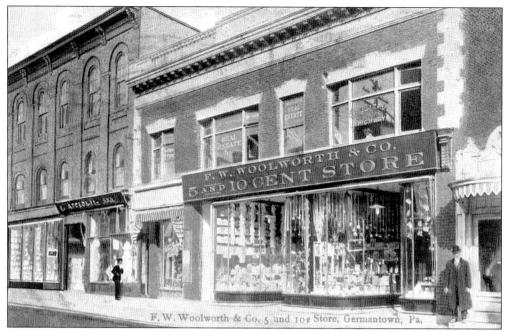

F. W. Woolworth's five-and-ten-cent store is located at 5611 Germantown Avenue in this 1911 postcard. Woolworth's was one of the first such concerns to take advantage of the concept of placing items in full view rather than behind glass counters and selling its merchandise at discounted prices.

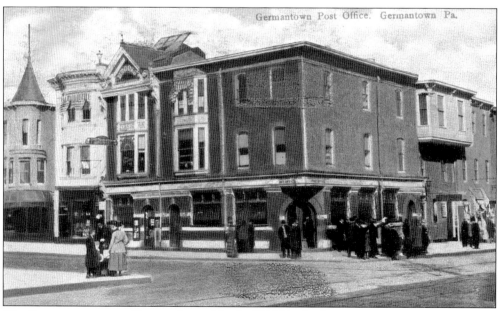

The Germantown post office was located in the 5700 block of Germantown Avenue at Chelten Avenue. This card is postmarked 1909.

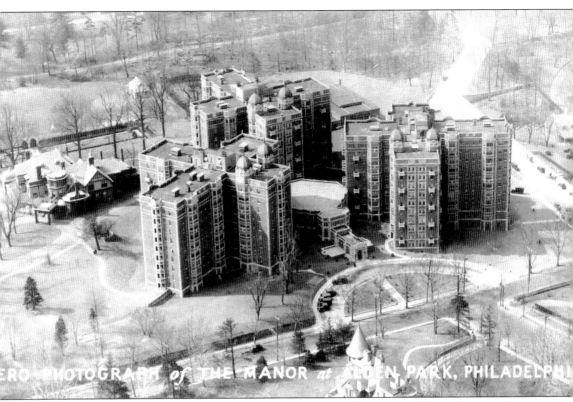

AERO PHOTOGRAPH of THE MANOR at ALDEN PARK, PHILADELPHIA

In 1925, ground was broken for Alden Park Manor on the site of the original 38-acre Strawbridge estate. Located at 5500 Wissahickon Avenue, it consisted of three apartment buildings, formal gardens, tennis courts, and a nine-hole golf course. This aerial view was taken shortly after the magnificent grouping was completed. Alden Park Manor was the first co-op apartment complex in Philadelphia.

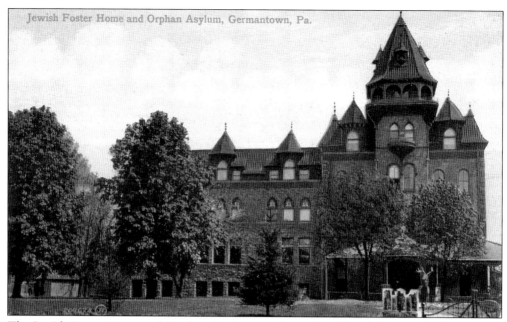

The Jewish Foster Home and Orphan Asylum was located at Church Lane and Chew Street. The home, originally on North Eleventh Street in Philadelphia, was founded by Rebecca Gratz. The 118 children living there in 1900 were all listed as "inmates." This is a 1904 view of the huge Victorian mansion.

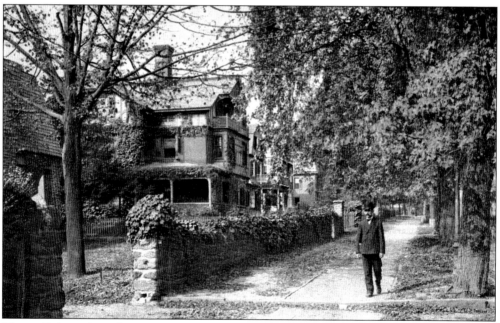

The well-dressed gentleman in this postcard is strolling down a peaceful Wayne Avenue. This area, located west of Germantown Avenue, was noted for its rich Victorian homes. The card was postmarked in 1908.

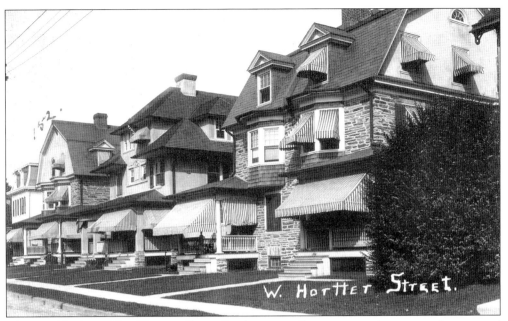

The 100 block of West Hortter Street lies between Germantown Avenue to the east and Emlen Street to the west. The stone-fronted single homes, seen in this 1910 view, sport nicely manicured lawns.

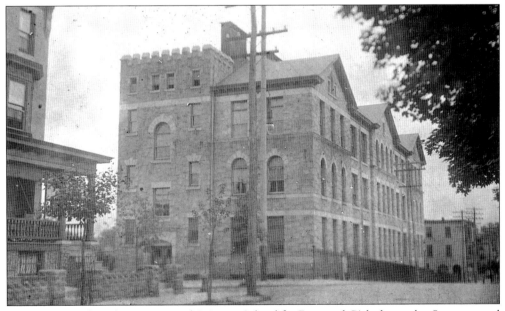

The Fitler Combined Grammar and Primary School for Boys and Girls, located at Seymour and Knox Streets in Germantown, is seen in this 1907 view. The school is named after Edwin H. Fitler, owner of the Philadelphia Cordage Company and mayor of Philadelphia in 1887. There remains a school at the above address now called Fitler Academics Plus.

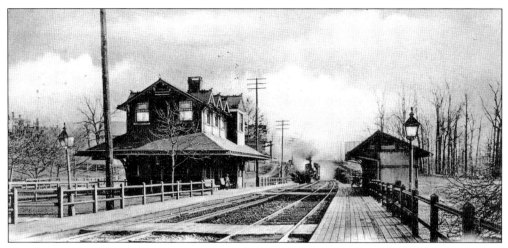

The Tulpehocken Station was a stop along the Philadelphia and Reading Railroad route between North Philadelphia and Chestnut Hill. This 1905 postcard shows the train stop surrounded by much open land. The station is currently boarded up and vacant.

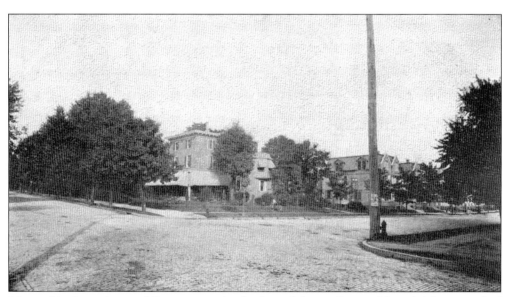

Mount Airy is northwest of Germantown beginning at Johnson Street, although it has never had exact, identifiable boundaries. Mount Airy was named after a mansion in the area that was built in 1750. This 1905 view shows the wide-open spaces at Mount Airy Avenue and Chew Street.

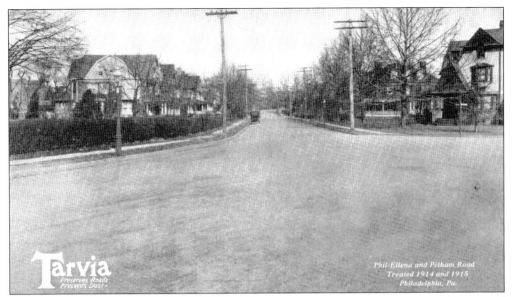

A 1915 advertising postcard for Tarvia, produced by the Barrett Company, manufacturers of coal tar products for street and roofing uses, shows the upscale Pelham section of Mount Airy. The area boasted Victorian and Colonial Revival houses and mansions, many with stained-glass windows and slate roofs.

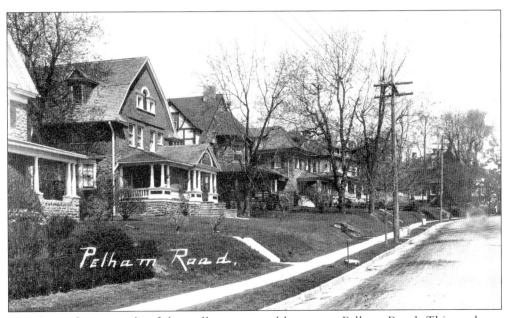

Here is another example of the well-constructed homes on Pelham Road. This card was postmarked in 1911 at the Mount Airy post office.

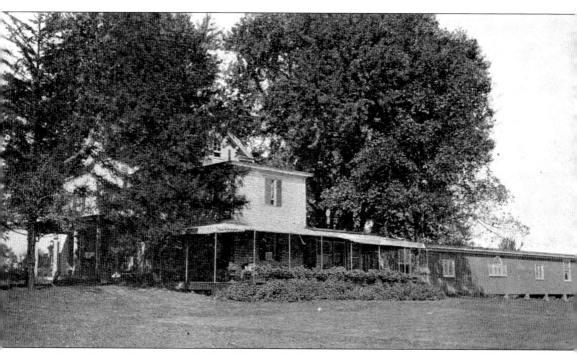

Since the northwestern suburbs still contained open green space, the area was ideal for golf courses. The Belfield Country Club was founded in Germantown in 1899. The Mount Airy Country Club is seen in this 1903 view. When the Mount Airy club closed, a number of its former members founded the Whitemarsh Valley Country Club in 1908.

Seven

THE OLD NORTHEAST
PHILADELPHIA

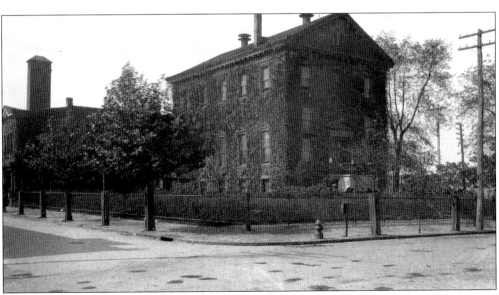

This cold, stark structure looked more like a schoolhouse than the 24th District police station. The building was located at 1832 East Cambria Street in Kensington. The card is postmarked 1907.

This house and corner store were located on East Dauphin Street. However, the cross street on the sign above the awning could not be deciphered. The stamp in this 1907 card was cancelled at the Kensington post office. Note the fire mark between the third-story windows.

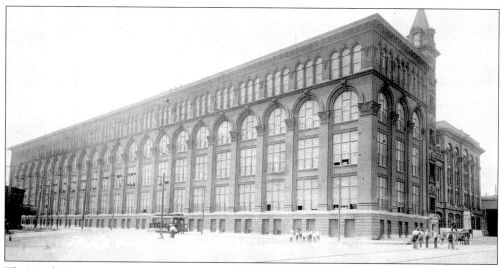

The North American Lace Mill was located at Eighth Street and Allegheny Avenue in the heart of the industrial area of North Philadelphia. This 1910 postcard shows its huge building complex.

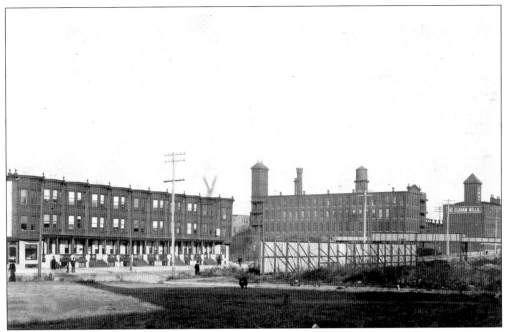

The Oldham Mills produced upholsterers' materials. It was located at East Allegheny Avenue and Boudinot Street in the Kensington section of North Philadelphia. The mill was situated in the midst of the homes seen in this 1907 view. The back of the card reads, "The house with the V is where we used to live."

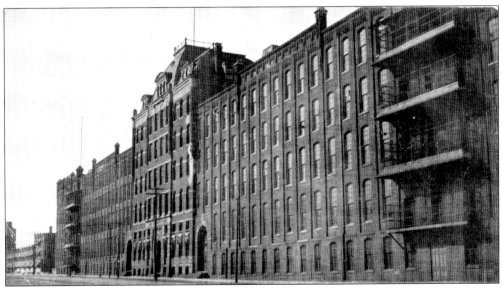

The Kensington section was noted for its large number of textile factories that existed there from the mid-1800s into the 20th century. John Bromley and Sons was prominent among carpet manufacturers. Seen in this 1904 view, the Bromley factory, located at Front Street and Lehigh Avenue, remained standing until 1979 when it was gutted by a massive fire.

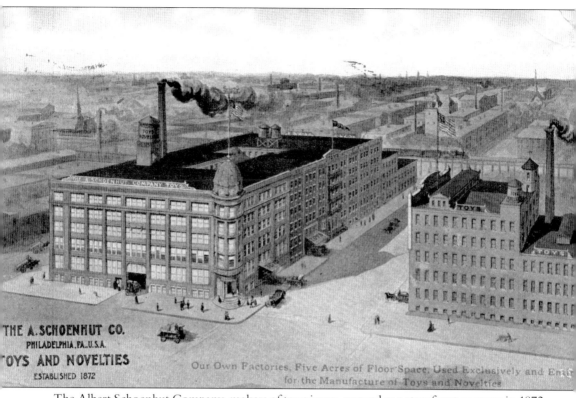

THE A. SCHOENHUT CO.
PHILADELPHIA, PA., U.S.A.
TOYS AND NOVELTIES
ESTABLISHED 1872

Our Own Factories, Five Acres of Floor Space, Used Exclusively and Entirely for the Manufacture of Toys and Novelties

The Albert Schoenhut Company, makers of toy pianos, opened as a storefront concern in 1872. By 1907, the company's five-story factory was producing giant dolls, model cannons, and other toy novelties. Seen in this 1909 postcard, the building complex was located in Kensington at Adams (now Hagert) and Sepviva Streets. It closed in 1935, having declared bankruptcy after the Depression.

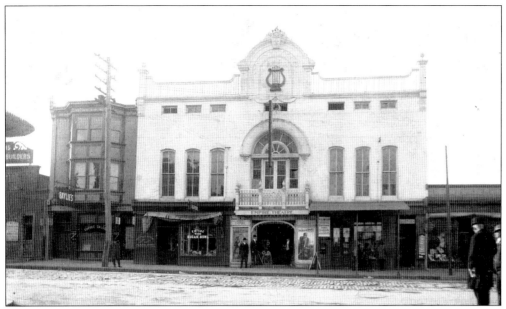

The Empire Theatre was located in Kensington at 4650 Frankford Avenue from 1901 until 1928. It is seen in this 1908 view.

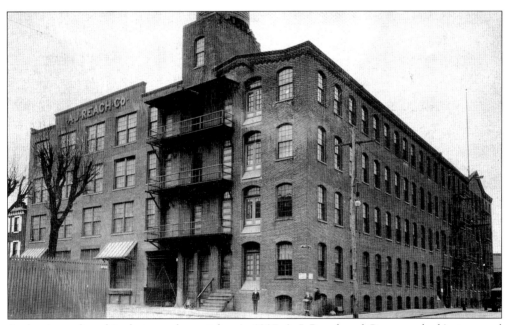

At the time when this photograph was taken in 1907, A. J. Reach and Company had just opened its factory doors in the 1700 block of Tulip Street in Fishtown. Reach was one of the largest producers of baseballs, footballs, and boxing gloves in the United States from 1892 until 1920. In 1916, Reach employed over 1,000 workers, as well as numerous Fishtown residents who sewed baseball covers in their homes.

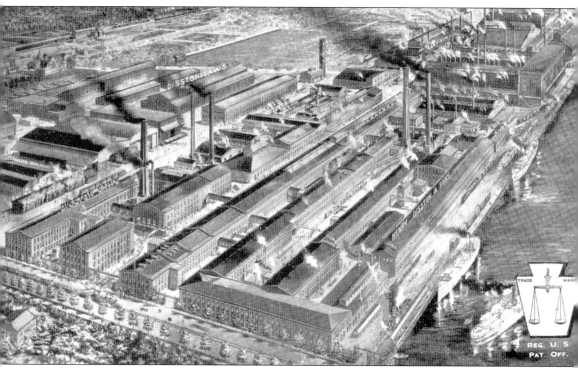

The Henry Disston and Sons Saw Works was located in the Tacony section between Princeton Avenue and Unruh Street east of State Road. The company opened in 1872 and was a family-owned business until it was sold in 1955. At its peak of activity, it boasted 2,500 employees. A manufacturer of massive circular saws and files, it also produced armor plating for tanks during World War II. Its massive 64-acre plant is seen in this view, postmarked 1914. The postcard shows an image of its factories pouring out clouds of black smoke from its smokestacks, which was at the time a sign of prosperity.

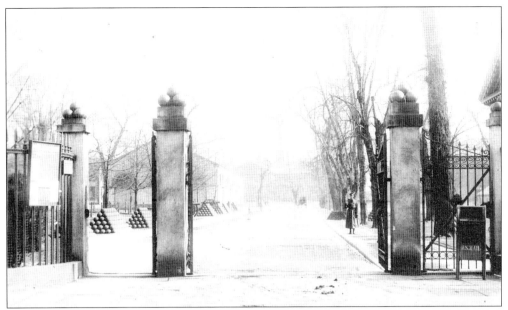

The Frankford Arsenal, located in the Bridesburg section of Philadelphia, derived its name from the fact that it functioned as the U.S. military's center for small-arms ammunition design and development. It opened in 1816 and saw its last usage by the federal government in 1977. During the First and Second World Wars, it employed as many as 20,000 workers. The main entrance is seen in a 1905 view.

This postcard was annotated, "Snowbound in Frankford Arsenal grounds during blizzard Christmas 1909." Since the front gate appears relatively unguarded in the previous photograph, it is likely that anyone could have gained access to the grounds for sledding.

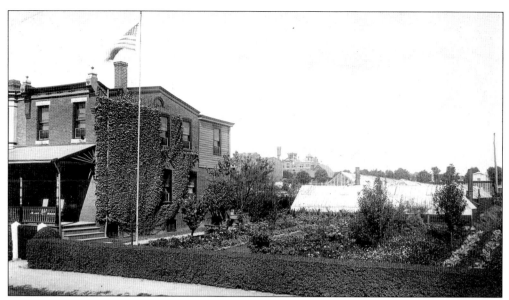

John Boylan and Sons were florists located at 5226 Jackson Street in the Frankford section, as seen in this 1910 view. In the far background, one of Frankford's many factories can be seen.

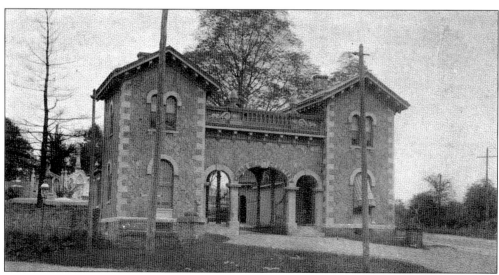

Cedar Hill Cemetery was founded in 1849. The main gatehouse, seen in this 1908 view, was erected in 1869. The cemetery is located at Frankford and Cheltenham Avenues.

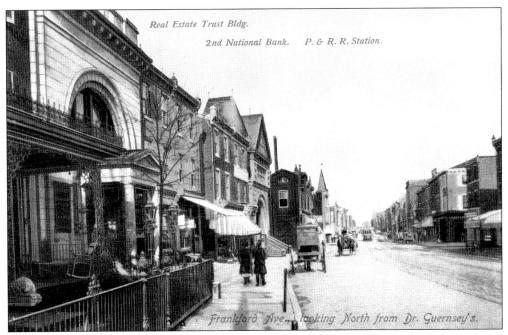

Frankford Ave., looking North from Dr. Guernsey's.

This 1906 postcard provides a panoramic view of the Frankford Avenue business district. The Dr. Guernsey referenced at the bottom of the card was William Jefferson Guernsey, M.D., whose office was located at 4342 Frankford Avenue. He is listed in the 1905 edition of the *Philadelphia Blue Book*.

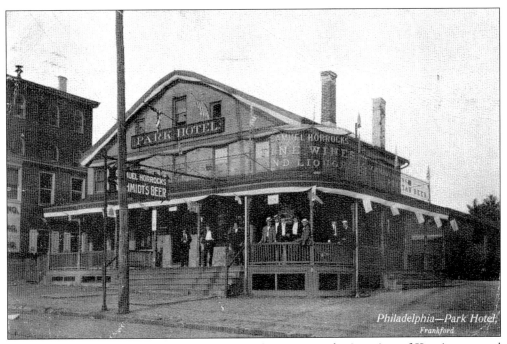

Philadelphia—Park Hotel, Frankford

The Park Hotel was located at 4217 Frankford Avenue at the junction of Kensington and Frankford Avenues, only a block from Guernsey's office. By 1908, it was apparent that the hotel had experienced better days.

101

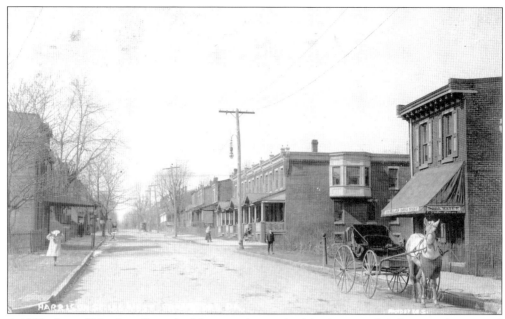

A 1908 view of Harrison Street looking west is seen in this photograph. The street lies several blocks southeast of the intersection of Frankford Avenue and Harrison Street. Alexander H. Gilfillan's drug store was located at 1829 Harrison Street.

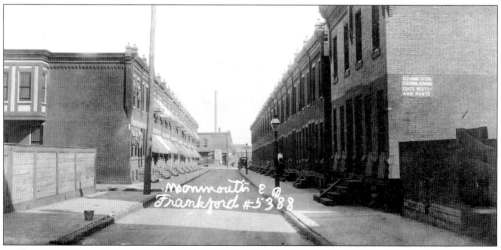

In this 1904 view, Monmouth Street dead-ends at Frankford Avenue, as seen in the far background. A sign advertises a tailor shop located within a private home.

Bellmore Avenue is located three blocks east of Monmouth Street. The distinction between an avenue and a street remains obscure, since Bellmore is no more than an extremely narrow passageway. It is seen in 1907, looking away from Frankford Avenue.

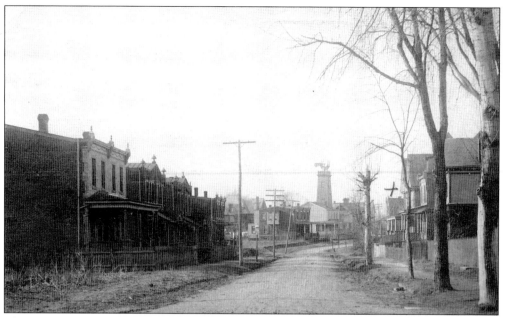

The Wissinoming area is north of Bridesburg, east of Frankford, and bounded by the Delaware River. The name is taken from the Native American word for "place where the grapes grew." Tulip Street, east of Vankirk Street, was already an older and rather run-down neighborhood when this photograph was taken in 1905.

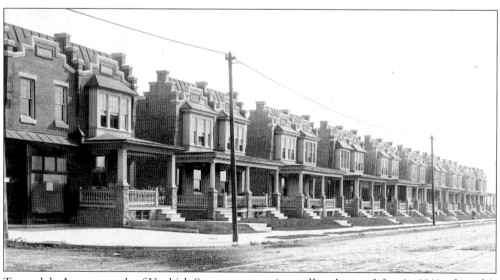

Torresdale Avenue south of Vankirk Street was a major trolley thoroughfare in 1911 when this photograph was taken. The twin homes sport small front lawns and are newer than those on Tulip Street, as seen in the previous postcard.

Eight

BRAVE NEW NORTHEAST

Contrary to popular belief, the Roosevelt Boulevard was named after Pres. Theodore Roosevelt, not Pres. Franklin Delano Roosevelt. Beginning at north Broad Street, it has always been the gateway to the greater northeast portion of Philadelphia. This 1911 view shows the boulevard at Broad and Cayuga Streets.

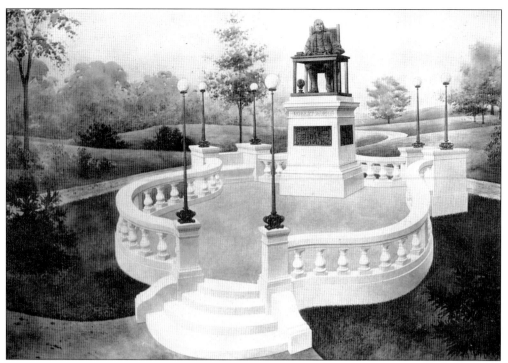

When this photograph was taken in 1914, the road was known as the Northeast Boulevard. This is the Robert Morris Monument by sculptor John Thomas, located at Fifth Street and the Boulevard. Notice the rolling hills in the background, the antithesis of the area's current appearance.

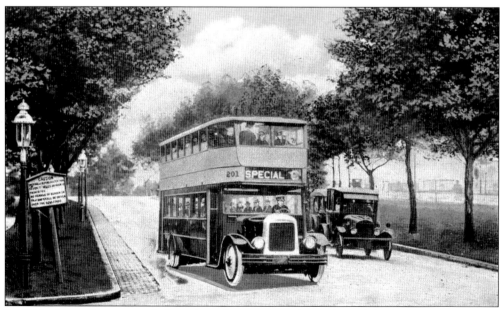

In 1918, the road was extended northward to Pennypack Creek, and the highway's name was officially changed to the Roosevelt Boulevard. In the 1920s and 1930s, extensive tracts of row homes, targeted for the middle class, were constructed. This 1920s postcard shows the light traffic and double-decker buses that traveled this route.

It is now impossible to imagine Roosevelt Boulevard as a newly developed road that is devoid of traffic, with an automobile parked alongside one of its inner lanes. This is a 1920s view of the Sears, Roebuck and Company plant on Roosevelt Boulevard. It required 13,000 pounds of dynamite to implode the building in 1994.

Mass transit was essential for workers commuting from northeast Philadelphia to Center City; double-decker buses were utilized in the 1920s along the Roosevelt Boulevard.

In 1926, Roosevelt Boulevard was designated as part of U.S. Route 1. Tourist homes, similar to today's bed-and-breakfasts, lined this road, which led to Bucks County and beyond. Mrs. J. T. Lange owned such an establishment at 5919 Roosevelt Boulevard, just above the Oxford Circle.

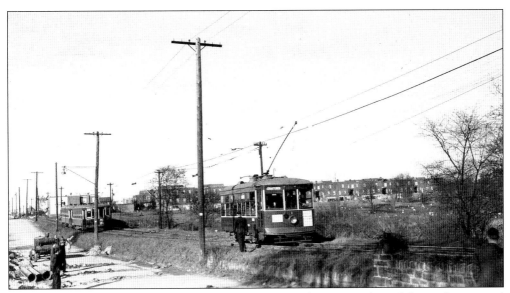

The trolley right-of-way is seen in this 1948 view near the intersection of Castor Avenue and Napfle Street. In the far background are the typical row homes of this area, which is also known as Castor Gardens.

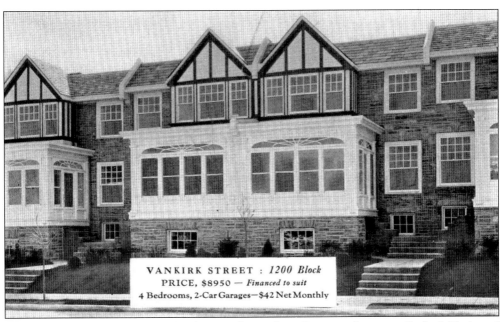

VANKIRK STREET : *1200 Block*
PRICE, $8950 — *Financed to suit*
4 Bedrooms, 2-Car Garages—$42 Net Monthly

P. J. and James T. Whelan were developers of a number of streets adjacent to Oxford Circle and the Roosevelt Boulevard north of Oxford Avenue and west of Castor Avenue. In the 1920s, advertising postcards were produced illustrating their various affordable styles of row homes. Those in the 1200 block of Vankirk Street had four bedrooms and two-car garages, selling for $8,950 (around $102,200 in 2006 dollars).

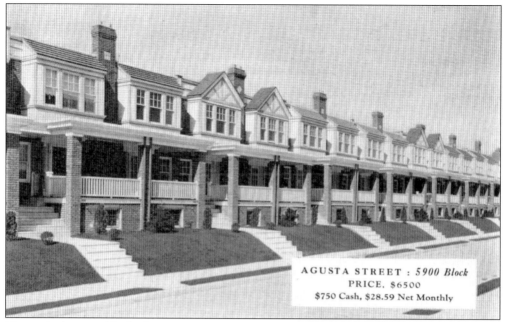

AGUSTA STREET : *5900 Block*
PRICE, $6500
$750 Cash, $28.59 Net Monthly

Houses in the 5900 block of Agusta Street sold for $6,500 (around $74,200 in 2006 dollars), with a down payment of $750 (around $8,560 in 2006 dollars), and a monthly mortgage of $28.59 (around $325 in 2006 dollars).

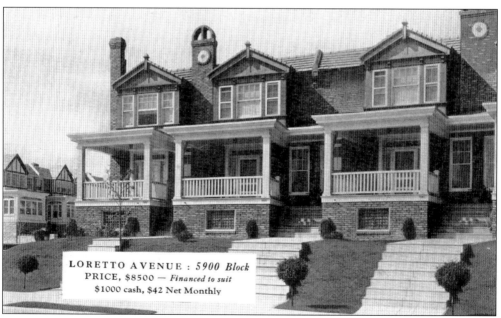

LORETTO AVENUE : *5900 Block*
PRICE, $8500 — *Financed to suit*
$1000 cash, $42 Net Monthly

Row homes in the 5900 block of Loretto Avenue were more expensive. A house could be purchased on this street for $8,500 (around 97,100 in 2006 dollars).

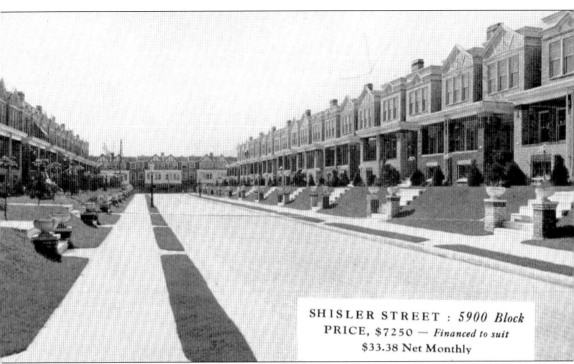

SHISLER STREET : *5900 Block*
PRICE, $7250 — *Financed to suit*
$33.38 Net Monthly

The width of the 5900 block of Shisler Street was 122 feet from porch to porch. Streets in the Oxford Circle area were wide since the developers made on-street automobile parking a priority; narrower streets in older areas of Philadelphia were victims of horse-and-buggy-era planning. The selling price of a house on Shisler Street was $7,250 (around $82,800 in 2006 dollars).

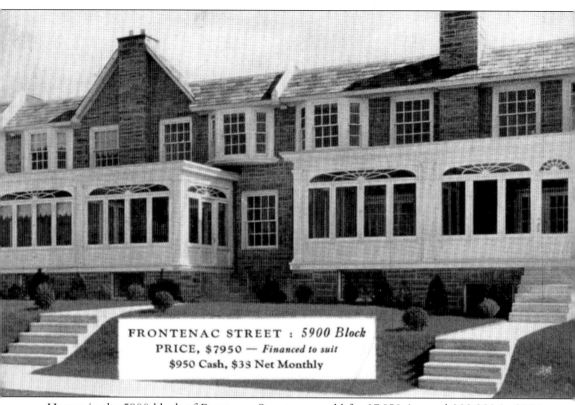

FRONTENAC STREET : *5900 Block*
PRICE, $7950 — *Financed to suit*
$950 Cash, $38 Net Monthly

Homes in the 5900 block of Frontenac Street were sold for $7,950 (around $98,800 in 2006 dollars). The developers advertised three and four bedrooms, one- and two-car garages, and thoroughly equipped kitchens. Noticeably, one of the inviting features of each development was the small grass lawn in front of each house.

Nine

GLIMPSES OF
SOUTH PHILADELPHIA

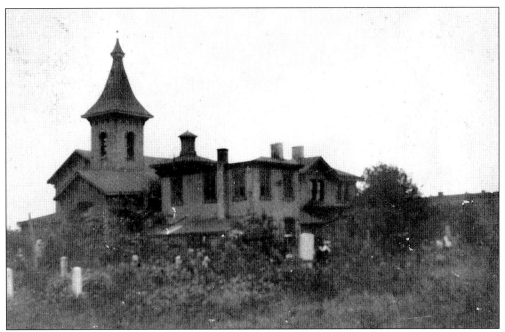

Passyunk Township was estimated to be an area of 5,110 acres. It derived its name from a Native American village and extended in an irregular configuration from the Schuylkill River portion of South Street to the Schuylkill River at Eighteenth Street. It was originally a boggy, marshlike area and, as such, was not prime land for development. The back of this 1910 postcard states, "This place [Nineteenth Street and Passyunk Avenue] was used for a long time as the Philadelphia potters' field. A number of Chinese are there also. Now they are digging up the bodies and putting a street through. It is right in back of our house."

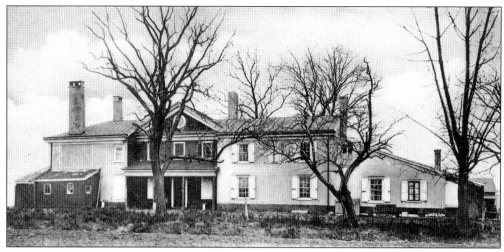

When Stephen Girard died in 1831, he was considered to be the richest man in the United States. His home, which he named Gentilhommiere, seen in this 1905 view, was located in Passyunk Township. Between 1906 and 1916, the area known as Girard Estates was established, and homes were built in the locale of Passyunk Avenue on the north, Shunk Street to the south, Seventeenth Street to the east, and Twenty-second Street to the west.

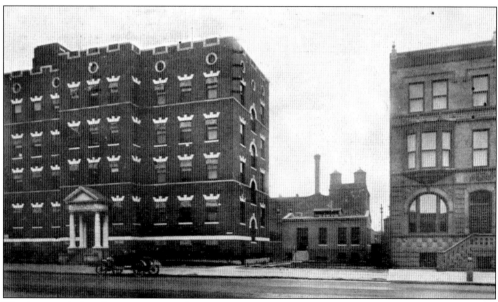

The Woman's Southern Homeopathic Hospital was located at 733–745 South Broad Street. In this 1923 postcard, the hospital building is seen at left, the nurses' home is on the right, and the laundry is in the middle background.

Mount Sinai Hospital was established in 1905 in a very congested, already well-established neighborhood at Fifth and Wilder Streets. Its initial purpose was to serve the great number of Jewish immigrants in the South Philadelphia area. In fact, the hospital was the first in the city to utilize Russian and Yiddish charts for eye refractions. It is seen in this 1920s postcard.

In 1902, Dr. Lawrence Flick expressed to philanthropist Henry Phipps that a tuberculosis sanatorium was needed in Philadelphia. When Flick mentioned building a small clinic on Lombard Street, Phipps retorted, "Buy the block, I will stand behind you." This postcard is a 1917 view of the Phipps Institute for Consumptives at Seventh and Lombard Streets.

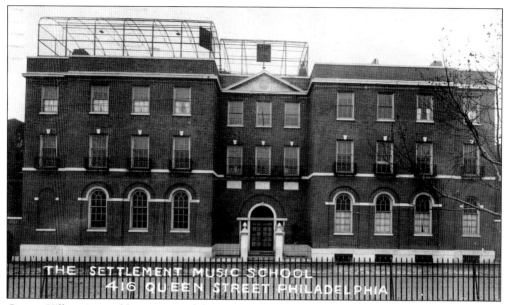

Queen Village is an older section of the city by virtue of its proximity to the Delaware River. Its boundaries are roughly below South Street, along the Delaware River, and to the vicinity of Eighth and Carpenter Streets. The Settlement Music School at 416 Queen Street was built in 1917 at the bequest of its benefactor, Mary Louise Curtis Bok Zimbalist, who understood the great need for a community-based school of the arts. Settlement Music School is now the largest such institution in the United States.

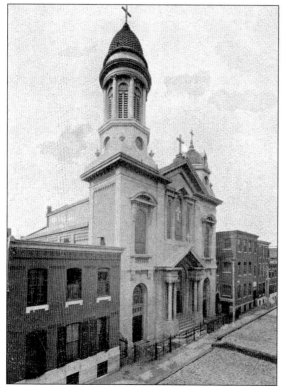

It is impossible to estimate the importance of the local church in the overall development of a community. St. Mary Magdalen Roman Catholic Church at 712 Montrose Street can be seen surrounded by neighborhood homes in this 1904 postcard. The church is located in Bella Vista, a section that lies between Sixth and Eleventh Streets and South Street to Washington Avenue.

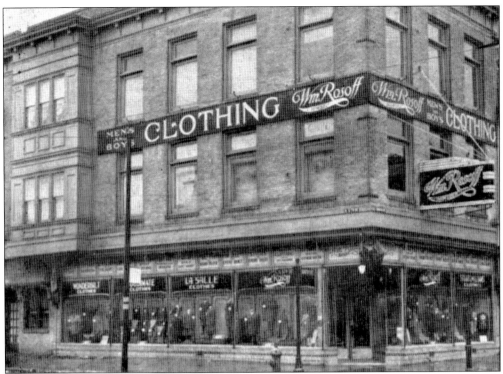

Philadelphia's Society Hill is bounded from Walnut to Pine Streets and the Delaware River to Seventh Street. In the first quarter of the 20th century, many Jewish merchants purchased the homes on South Street and converted them into thriving businesses. Seen here is William Rosoff's clothing store on the southwest corner of Fifth and South Streets, around 1920.

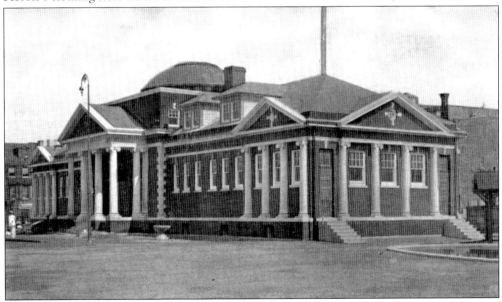

Only two blocks from Rosoff's store is Starr Garden Park, located between Sixth and Seventh Streets on Lombard Street. This advertising postcard from about 1908 calls it "Philadelphia's newest gift to the play activities of her people."

In the first decade of the 20th century, the Free Library of Philadelphia published an extensive series of postcards illustrating its various branch locations. Seen here is the Southwark branch, located on the northwest corner of Fifth and Ellsworth Streets.

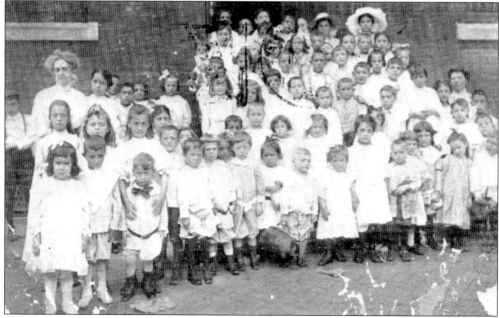

South Philadelphia has always been known for its diverse communities and ethnic groups. These young persons were members of the 1910 Italian mission study class of St. Peter's Evangelical Lutheran Church at Ninth and Reed Streets.

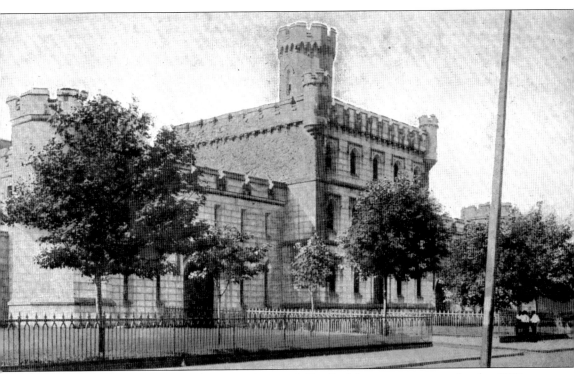

When Moyamensing Prison, with its imposing, castlelike Gothic towers, was completed in 1835, it was surrounded by open countryside. As the southern portion of the city continued to expand, homes were built in very close proximity to the prison. Located at the junction of Tenth and Reed Streets and Passyunk Avenue, it remained in use until 1963 and was finally demolished in 1968. It is rather frightening to note that the children in the preceding photograph were standing only one block away from the prison walls.

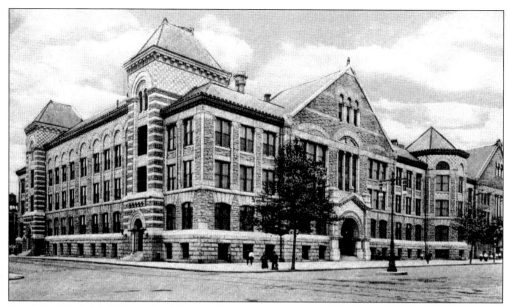

South Philadelphia High School, located at Broad Street and Snyder Avenue, is seen in this 1911 view. The school opened in 1907 and was divided into boys' and girls' buildings. The school was known for producing many professional musicians and singers, such as Mario Lanza and Marian Anderson, as well as a great number of noted sports figures. In the mid-1950s, the buildings were demolished and replaced by a coeducational school.

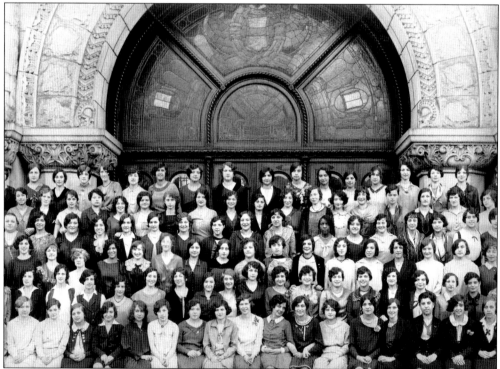

This is a photograph of the 1930 class of South Philadelphia High School for Girls. They are posed in front of the ornate main entrance to the girls' side of the school.

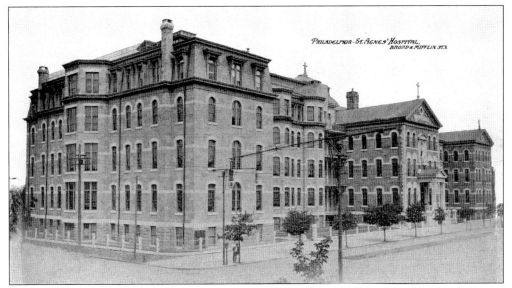

In 1876, the southern end of Broad Street was a dumping ground, with the land being marshy and infested with mosquitoes. This wasteland at Broad and Mifflin Streets was chosen as the spot to erect St. Agnes Hospital. The original portion of the institution was built in 1879; the new addition, seen in this 1907 postcard, was completed in 1905.

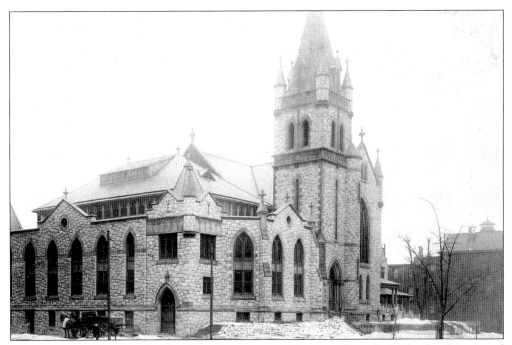

St. Luke's Church at Broad and Jackson Streets, across the street from the high school, is viewed in this card postmarked 1906. The corner site on which St. Luke's Church stood has been replaced by a bank. In the next block, on the far right, can be seen one of the magnificent homes that lines south Broad Street.

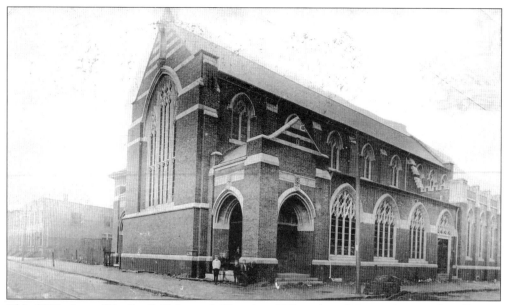

This 1907 view of St. Paul's Episcopal Church at Fifteenth and Porter Streets also allows a glimpse of the neighboring homes, as seen on the far left. The church is located several blocks southwest of South Philadelphia High School.

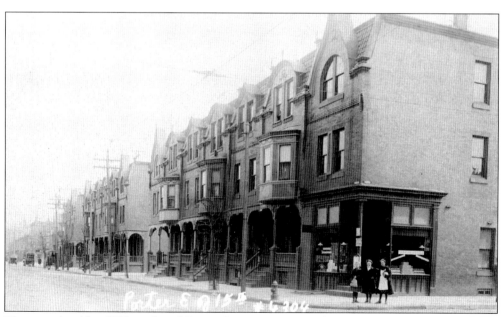

The opposite side of Fifteenth and Porter Streets, just across from St. Paul's Episcopal Church, is seen looking toward Broad Street. This postcard is from around 1908.

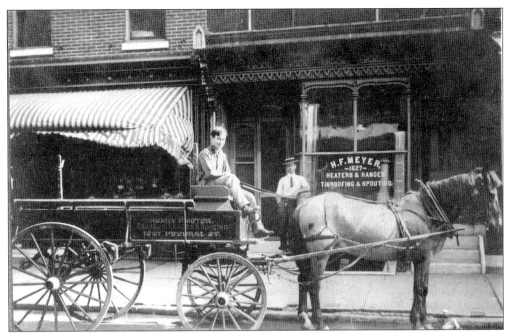

Whether posing for the camera or ready for work, a smiling young man sits atop a wagon in front of Henry F. Meyer's store at 1627 Federal Street. In 1914, Meyer specialized in roofing and heating repairs.

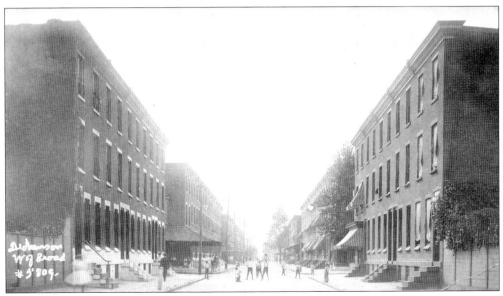

Dickinson Street is 15 blocks south of city hall. Dickinson Street west of Broad Street is seen in this 1907 photograph. The brick-front three-story row homes are typical of the area. The boys play a game of street ball, which is a South Philadelphia sport that has never changed.

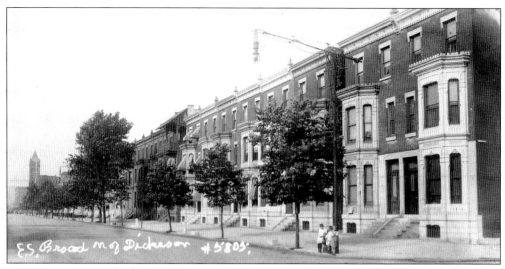

In great contrast to the homes seen in the previous photograph, the intersection of Broad and Dickinson Streets was far more elegant and appealing. Broad Street is viewed in 1907, looking north toward Center City.

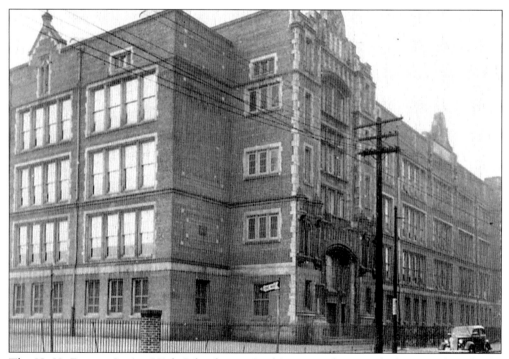

The H. H. Furness Junior High School, seen in this 1940s photograph showing the school's exterior and playground, is located at the corner of Third and Mifflin Streets. The school is now called Furness High School.

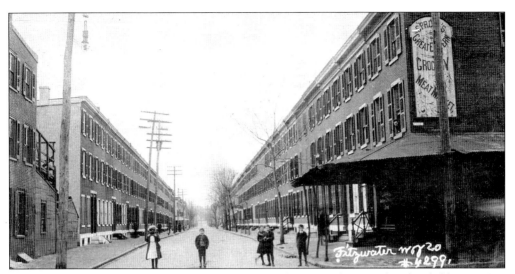

Fitzwater Street west of Twentieth Street is seen in this 1908 photograph. The children posing for the photographer are nicely groomed. The dwelling in the left foreground is decidedly older and shabbier than those further down the street.

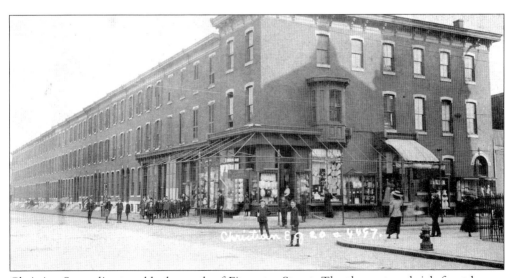

Christian Street lies two blocks south of Fitzwater Street. The three-story brick-front homes appear well maintained, and the onlookers are fashionably dressed. This is a photograph from about 1907 of Twentieth Street east of Christian Street.

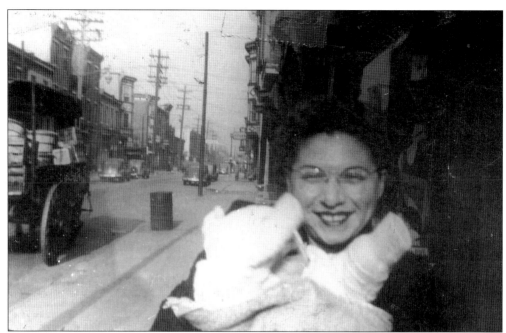

This is a photograph of the author at age three months in the arms of his mother, Leah Wolfberg Spector. Taken in January 1944, the view faces northward on South Seventh Street north of Morris Street. This area of South Philadelphia was a haven for eastern European immigrants.

This 1950 view of the 300 block of Roseberry Street looks east toward Third Street. Roseberry Street, which is one block long, is sandwiched between Third and Fourth Streets and Ritner and Porter Streets. The homes were approximately 50 to 60 years old when this photograph was taken. The cute little mutt sitting on the step was Tarzan, the author's dog.

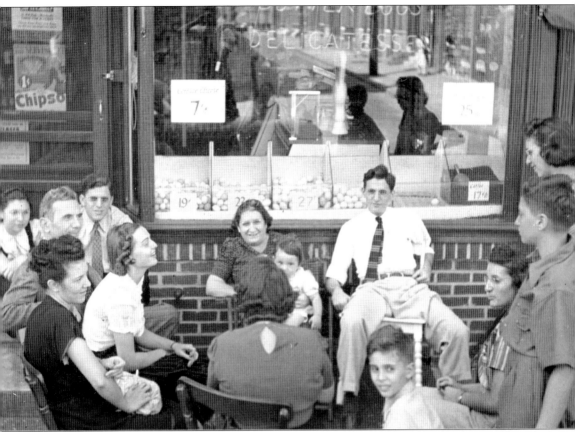

The Wolfberg family operated a dairy store at 1634 South Seventh Street, located between Morris and Tasker Streets in the 1930s and 1940s. Posing for the camera while holding a child is grandmother Gussie Wolfberg, after whom the author was named. The author's mother sits at the far left, and the author's father, Philip Spector (wearing glasses), sits next to her. The opposite side of Seventh Street can be seen in the store window's reflection. (Arlene W. Farber.)

ACROSS AMERICA, PEOPLE ARE DISCOVERING SOMETHING WONDERFUL. *THEIR HERITAGE.*

Arcadia Publishing is the leading local history publisher in the United States. With more than 3,000 titles in print and hundreds of new titles released every year, Arcadia has extensive specialized experience chronicling the history of communities and celebrating America's hidden stories, bringing to life the people, places, and events from the past. To discover the history of other communities across the nation, please visit:

www.arcadiapublishing.com

Customized search tools allow you to find regional history books about the town where you grew up, the cities where your friends and family live, the town where your parents met, or even that retirement spot you've been dreaming about.